GIUSEPPE MARINELLI

MONA NATURE

Mona Lisa and the four Elements

All the images published in the essay are taken from public domain resources or directly authorized by the owners. The author-publisher is available to any holders of rights that have not been identified or fulfilled.

Copyright © 2019 Giuseppe Marinelli

All rights reserved.

CONTENTS

1 *INTRODUCTION*

CHAPTER ONE

5 A NOT-PORTAIT

8 Which woman?
25 Which landscape?
39 *Mona Lisas* and the others
50 From reality to allegory. A conceptual portrait

CHAPTER TWO

57 LEONARDO AND THE FOUR ELEMENTS

58 Earth, Water, Air, Fire
80 The *Mona Lisa* and the theoretical model of the four Elements
90 The four Elements and the Leonardo's theory of colours
95 Leonardo and Alchemy

CHAPTER THREE

111 MONA NATURE

119 *NOTES*

133 *BIBLIOGRAPHY*

141 *INDEX*

INTRODUCTION

> *If you despise painting, which is the sole imitator of all the visible works of nature, it is certain that you will be despising a subtle invention which with philosophical and ingenious speculation takes as its theme all the various kinds of forms, airs, and scenes, plants, animals, grasses and flowers, which are surrounded by light and shade. And this truly is a science and the true-born daughter of nature, since painting is the offspring of nature. But in order to speak more correctly we may call it the grandchild of nature: for all visible things derive their existence from nature, and from these same things is born painting. So therefore we may justly speak of it as the grandchild of nature and as related to God Himself.*
>
> (LEONARDO DA VINCI, *A treatise on painting*)

Another essay about *Mona Lisa*! How may the most famous and studied painting in the world still reserve some unpublished issues or arguments for further studies? Yet, minding the gigantic mass of monographs, pamphlets, pages, films, websites, which the Louvre wooden panel has aroused and keeps on to arouse, it would seem that the last word on the woman painted by Leonardo has not hitherto been

said.

By now it is common opinion that *Mona Lisa* matchs to the mistery. A mystery that, at all costs, *should be* there: it is so for the criticism that from Vasari onward has made enormous efforts to try to guess the identity of the woman or, more recently, to identify the place depicted into the landscape behind her. It is a mystery to the common feeling, magnetically attracted by the alleged enigma of her famous smile, look, and singular physiognomy – I do not want to add forth more words to the *mare magnum* of expressions and phrases that describe them –; and it is especially for all kinds of imaginative writers, filmmakers, speculators, who contribute to perpetuate the myth of the alleged mystery of *Mona Lisa* for vulgar lucrative purposes. As if that smile and that face lent themselves in the same way to be the right crowning, the sophisticated and learned *coup de théatre*, for any kind of enigma or mystery, true, presumed or totally invented, ignoring more or less consciously the real historical and cultural conditions that gave rise to that kind of portrait and that figure.

This essay does not aspire to explain the ultimate and inescapable interpretation of the *Gioconda* 'secret subject', nor to provide conclusive proofs of the identity about the woman and the places depicted by Leonardo: to clarify these issues will not contribute the critical deductions or, worse, the assumptions blooming from other parts, but only new documentary discoveries, which I hope will happen soon. On the contrary, it wants to be a tribute to the genius of Leonardo, at a time when a certain criticism, mainly from beyond the Alps, tends to reduce his scope in the name of a petty-bourgeois 'bookkeeping' perspective that evaluates it on the basis of his achieved results, and emphasizes the utopia of some projects, the scarce originality of many conceptual contents, the lack of productivity or method,

INTRODUCTION

the great concessions to medieval culture, and so on.

Charges, however, already partially dealed during his time, that have not prevented his contemporaries and even Vasari to award him a «divine» personality. In their judgment, the only one able to catch the originality and value of his person with respect to his time, that I want to rely for my personal tribute, rather than to the ideas of a certain criticism of today, warped, indeed, by ideological prejudices and reductive intentions summarily expressed from the top of today's knowledge. Just the belief in his contemporaries' remarks prevent me, on the other hand, from falling into the trap of Leonardo's myth as precursor at any cost of modern engineering, scientific, medical disciplines, or, worse still, from contributing to perpetuate the romantic *legenda negra* as an agnostic, heretic scientist, or as a esoteric magician and initiated to the mysteries of the Cosmos.

A serious and detached reflection about the personality and the legacy of the Vinci genius is therefore required; the chance is now the five hundredth anniversary of his death, which took place on 2 May, 1519, at whose celebration this essay ideally wish to partake.

This tribute could not therefore be dedicated to nothing but the *Gioconda*, to the masterpiece that, more than any other, might be accounted as the *summa* of Leonardo's painting and genius and, perhaps for this reason, consciously held by himself for part of his existence to the end, as a faithful and intimate companion of life. Far from the intention to solve the alleged 'mystery' of the most famous portrait in the world, this critical contribution of mine only goes into the meanderings of Leonardo's painting to show just through *Mona Lisa*, as a case among others, his whole conceptual richness that has no comparisons with any artists from the past or the present.

Inevitably, it will be a matter of summarizing the results of

the research on the characteristic data of the portrait which, obviously, have also to be compared with some of the main hypotheses about the identification of the woman and the places depicted behind her. The compositional analysis of the landscape will lead, also through the comparison with the copies and the different versions of the *Gioconda*, to set a new interpretation key, that of the allegory, which allows to realize that the Aristotelian theory of the four Elements, on which Leonardo placed most of his naturalistic speculation, is concealed in the landscape scenary.

Thanks to this reading emerges, in the final chapter, the secret 'subject' of the paintings and the allegorical character of its whole composition, that are referring to the model of a Great Mother Nature who, through the smile and the gaze of Monna Lisa Gherardini, invites to meet this maternal, provident, but also terrible 'lady of the Cosmos', namely *Mona Nature*.

Bologna, 2 May 2019

CHAPTER ONE

A NOT-PORTRAIT

I believe writing about Leonardo is one of the most difficult tasks than ever to a scholar. Too many words have been spent, in a literary production to say the least gigantic, with incomparable style and unparalleled prose by many famous authors (Pater, Clark, Kemp, Pedretti, Marani, Sgarbi an so on) that the mere purpose to compete with them pales and discourages any attempt. Especially when this task is related to the famous portrait of a woman known as the *Gioconda*, or *Mona Lisa*, which has become the icon-symbol of painting itself, accounted as supreme climax of ancient art (and therefore also much mocked), assumed as *pop-stars* and *kitsch* deity into the contemporary subculture, for which it does not need to grapple with new descriptions, analyzes, elegies, locutions, which can be added to those already spent. The theme's greatness requires, therefore, us to enter on tiptoe, with extreme courtesy, almost whispering, and with a certain embarrassment, in the awareness of not being able to comprehensively confront at all with the endless critical literature dedicated to this portrait, nor to suggest its definitive and exhaustive analysis, also in the light of the many plot twists

that this fascinating woman does not stop to reserve and that, perhaps, will still surprise us in a future.

According to the vulgate, the *Gioconda* is synonymous with mystery. It is so for the common feeling that recognizes the presence of a *quid* that goes beyond the simple 'portrait of a woman with landscape' and gives rise to a publicistic, literary, cinematographic, inexhaustible production, halfway between truth and fiction, reality and fantasy. Actually, a kind of enigma hovers in that small panel (77 x 53 cm.) of Italian poplar, oil-painted by thin color veils almost without white pigment, which is now retained at Louvre in Paris (inventory number 779 - formerly MR 316). From the point of view of critical studies, its mysteries concern rather 'technical' details: the matter about the recognition of the sitter was solved only recently (to the traditional identification with Lisa Gherardini, Francesco del Giocondo's wife, has been added at least a dozen of other authoritative alternative proposals); there are no explicit documents (contract, exchange of letters, payments) concerning the portrait, nor notes or preparatory sketches in Leonardo's codes. Even new archival investigations, among which the very accurate ones by Giuseppe Pallanti[1] stand out, carried out on both the alleged protagonists of the commission, namely Francesco del Giocondo and Lisa Gherardini, who have highlighted every detail of their family history, have not come to demonstrate that Leonardo has ever taken on the portrait-painter assignment, or to reveal a connection among them that would make it presuppose. The issue on acquisition of the masterpiece in the king of France's picture gallery is still not clarified and, above all, it has to be explained why Leonardo never gave the portrait to his legitimate client, holding it always with him in a state of steady elaboration. Even admitting a withdraw by the patron or the occurrence of some circumstances (in this case, the public

commission of the *Battle of Anghiari* can be sued) such as to dissolve, mutually and consensually, the reciprocal agreements, we do not realize why Leonardo longed howsoever to complete this portrait, whereas it is known that the incompleteness of his paintings was certainly not his main concern.

There are also contradictory or atypical elements in this portrait's iconography, such as the absence of sitters's wedding ring or other distinctive signs of her social *status*, the clothing that is quite different from the contemporary and almost impersonal model, the dark veil on the head that could indicate a sign of mourning incompatible with the biography of Lisa Gherardini, finally, the fanciful and surreal landscape behind her.

From the point of view of the common people the evident inconsistencies and singularities of the portrait about the pose, the look, and, above all, the queer smiling expression, merged with the timeless romantic myth of Leonardo as artist-magician, agnostic scientist who knew any secrets of the universe, almost owner of an initiatory wisdom, which created around the *Mona Lisa*, thanks to the sudden popularity due to the famous theft in 1911, what may be considered the first worldwide *mass-medial* legend, that has justified till today any possible fantasy.

Throughout the people, scholars and devotees, however, is standing the awareness – which solicits every possible ideal supposition – about the *Gioconda*'s exceptionality, at least, due to its evident contravention to the contemporary portraiture's basic rules that certainly would provided for a commission settled by stricts agreements about remuneration and submittion times. It seems anomalous that Leonardo could have took the liberty to hold it with him and then allow himself an indefinite time for its completion, assuming an utter autonomy that would have been unusual in the professional practice of the early sixteenth century.

Chapter one

This is the starting point that leads me to state that the *Mona Lisa* is actually a *non-portrait*, because it by the portraits takes only the formal iconographic rules, but not the inherent dynamics by its typology, which would have provided a regular commission with his final consignment, as Leonardo himself dealt with his every portrait. Except for the *Gioconda*.

Which woman?

For a long time the mystery of the *Gioconda* has matched with the attempt to outline the 'identity card' of its depicted woman: her birth, name, surname, origins, paternity, marital status and especial signs (clothing, pose, etc.) have been the matters for an inexhaustible documentary and analytical research.

The critical fortune of the painting and its mystery began in 1550, with the first edition of Giorgio Vasari's *The Lives of the Most Excellent Painters, Sculptors, and Architects*, in which the famous biographer and artist describes the portrait with these following memorable expressions[2]:

> *For Francesco del Giocondo, Leonardo undertook to paint the portrait of Mona Lisa, his wife, but, after loitering over it for four years, he finally left it unfinished. This work is now in the possession of the King Francis of France, and is at Fontainebleau. Whoever shall desire to see how far art can imitate nature, may do so to perfection in this head, wherein every peculiarity that could be depicted by the utmost subtlety of the pencil has been faithfully reproduced. The eyes have the lustrous brightness and moisture which is seen in life, and around them are those pale, red, and slightly livid circles, also proper to nature, with the lashes, which can only be copied, as these are, with the greatest difficulty the*

eyebrows also are represented with the closest exactitude, where fuller and where more thinly set, with the separate hairs delineated as they issue from the skin, every turn being followed, and all the pores exhibited in a manner that could not be more natural than it is: the nose, with its beautiful and delicately roseate nostrils, might be easily believed to be alive; the mouth, admirable in its outline, has the lips uniting the rose-tints of their colour with that of the face, in the utmost perfection, and the carnation of the cheek does not appear to be painted, but truly of flesh and blood: he who looks earnestly at the pit of the throat cannot but believe that he sees the beating of the pulses, and it may be truly said that this work is painted in a manner well calculated to make the boldest master tremble, and astonishes all who behold it, however well accustomed to the marvels of art. Mona Lisa was exceedingly beautiful, and while Leonardo was painting her portrait, he took the precaution of keeping some one constantly near her, to sing or play on instruments, or to jest and otherwise amuse her, to the end that she might continue cheerful, and so that her face might not exhibit the melancholy expression often imparted by painters to the likenesses they take. In this portrait of Leonardo's, on the contrary, there is so pleasing an expression, and a smile so sweet, that while looking at it one thinks it rather divine than human, and it has ever been esteemed a wonderful work, since life itself could exhibit no other appearance.

Thus begun the worldwide myth of Lisa Gherardini, second wife of Francesco del Giocondo, as the woman depicted by Leonardo in the Louvre wooden panel. But the mystery of the woman portrayed by Leonardo also begun, because the Vasari's description, done as object of a real critical dissection, contains many inaccuracies and inconsistencies, to the point that some scholars have been bent to diminish it and promote others identity assumptions. Some of them emphasized on eyelashes and eyebrows that, although Vasari describes in detail, are missing, on the inaccuracy of the red cheeks, and his declaration to be an «unfinished», that is, incomplete, portrait, whereas actually it should have been already during his time in the same degree

of entirety that is appreciated still today – unless the heavy consequences due to the time and the cleaning and restoration interventions – and, anyway, worthy to be purchased by a sovereign like Francis I of France. I point out that Vasari focuses only on the «head», while he avoid mentioning the landscape, which nonetheless plays the attention of anyone looking at the painting and certainly would not have escaped the eye of an expert critic and skilled artist as him, even for its oddness compared to ancient portraiture rules. The only reliable explanation is that Vasari never saw the original painting of *Monna Lisa* but perhaps a copy or an elaboration of it, or – this is the most common authoritative reason that I agree – he drew on some oral or written description transmitted by others, on which the biographer granted himself some of his usual personal interpretations.

The explanation that Vasari gives on the origin of the famous «grin» of the woman seems obviously fanciful and simplistic, it not taking into account the fact that Leonardo had impressed the same smiling expression on his last works, as in Saint Anne and in the Virgin at Louvre, in the *Virgin of the Rocks*, in *Bacchus* and in *St. John* still at Louvre, but also in the *Lady with an ermine*, and he was intentionally transgressing – and here the Vasarian comment becomes absolutely pertinent – the conventions of good Italian figuration, which imposed on the contrary a serious, austere and monumental attitude, suitable to express the sitter's 'virtuous' soul[3], that even the young Leonardo proves to initially follow: «VIRTUTEM FORMA DECORAT» («beauty adorns virtue») is the *motto* that Vincian reproduces rear the wooden panel where he portrayed Ginevra Benci (1475). An iconographic reform, that of the grins and of the 'smiling Madonna' of maturity, which remained however unheard and isolated, except among the direct pupils of Leonardo, so much that

his contemporary Raphael preserved the traditional severe and rigorous expression in the people he portrayed, even when they are explicitly referred to the *Gioconda* sample.

Taking into account that the painting was begun, as we will see further, in 1503, the indication about four years of elaboration till Leonardo left unfinished («*imperfetto*») the picture allows, I suppose, to believe that Vasari has drawn his news from a descriptive source that should date back to the years 1507-8, at the time of an another return by the Vincian from Milan (where he had been re-called in May 1506 by the French governor Charles d'Amboise) in Florence, in order to regulate the dispute against his relatives about the inheritance of his uncle Francesco[4]. At that time, Leonardo was dwelling with his charming disciple and assistant Salaì (Giovanni Giacomo Caprotti from Oreno, known as Salaì or Salaìno, by the name of a protagonist demon of *Il Morgante* by Luigi Pulci, for his restless and sometimes unfair behaviour) into the palace of a wealthy patron, Piero di Braccio Martelli, where the sculptor Giovanfrancesco Rustici also was living. The latter, having an original and extravagant personality, and an attraction to alchemy and esotericism, could have submitted Leonardo into a group of goliard artists, called «*Compagnia del Paiolo*», to which many of his contemporary colleagues, such as Andrea del Sarto and Aristotle da Sangallo, shared[5]. I suppose that in that cheerful company, in whom Leonardo seems to have been perfectly at ease, his paintings still in progress might have been known and have aroused a great interest and so also elicit every kind of descriptions, comments, praises, which would be circulated also in written, and grounded the source for Vasari's account. So it is clear that his mention of musicians and «buffoons» who would entertain the alleged *Gioconda* appears the result of a goliardic rumor, fully compliant with the spirit of the cheerful company, more than a reliable in-

dication gave by some distinguished commentator, as Paolo Giovio[6] or by a Gherardini's relative, still alive in Vasari's time[7] – the discovery of the act of inhumation of Mona Lisa Gherardini del Giocondo into the church of Sant'Orsola in Florence dates at 15th July 1542 her death[8] –, or, at most, a result of the free imaginations by the Arezzo biographer due to the contents of his own references, which does not take into account the Vincian's figurative researches.

Then, let's go back to the mystery of the Louvre woman's identity. Vasari's commentary and his blatant incongruity prompted scholars to search other reliable documentary sources; the early indication that, in absolute chronological order, regards the portrait was only discovered in 2005 by Armin Schlecter: it is a written note by Agostino Vespucci, nephew of the most famous Amerigo, secretary of Machiavelli and assistant to the Florentine Chancery, political and humanist himself, rather well known in the early sixteenth century, in the margins of an copy of the Bolognese edition of 1477 by Cicero's *Epistulæ ad Familiares* preserved in the Heidelberg University Library, where, alluding to an unfinished work by Apelles, he expresses a doubtful judgment about Leonardo's ability to finish his works, including the Lisa del Giocondo's «head» («*caput*»)[9]:

> *Apelles the painter. That is what Leonardo da Vinci does in all his pictures, as in the head of Lisa del Giocondo, and Anne, the mother of Mary. We will see what he will do in the hall of the great council, about which he had made an agreement with the standard bearer. 1503. October.*

As this comment quotes a historically certain date and circumstances relating to Leonardo's allocation for the *Battle of Anghiari's* fresco, it can be believed absolutely reliable to realize that

even before October 1503 Leonardo has been painting the portrait of Lisa Gherardini del Giocondo and that this was widely known in the Signoria's *entourage*[10]. The testimony of Vespucci dispels any doubt about the fact that Leonardo really did the portrait of the Florentine silk merchant's wife and, if crossed with Vasari statements, it leads one quite likely to think that this portrait is just what was got – in unclear circumstances, as we will see – to the Fontainebleau's gallery.

Before the marginal note by Agostino Vespucci was discovered, the account by Antonio de' Beatis about the visit of Cardinal Luigi d'Aragona to Leonardo's study at his residence at Clos Lucé in Amboise, which took place on October 10, 1517, was been in great regard. De' Beatis, who was employed as secretary of the prelate, noted in his diary a lot of interesting remarks about the painter's health conditions, especially about his infirmity in the right hand for a showed up «certain paralysis» (on which, however, we doubt today, since Leonardo was left-handed from his birth), and described the paintings displayed to the cardinal, perhaps only a few amongst those owned in his studio, in this way[11]:

> *Our master went with the rest of us to one of the precincts to see Messer Leonardo da Vinci, and old man of more than seventy, the most outstanding painter of our age. He showed to His Excellency three pictures, one of a certain Florentine woman portrayed from life at the behest of the late Magnificent Giuliano de' Medici, another of St John the Baptist as a young man, and one of the Madonna and Child set in the lap of St Anne, all most perfect.*

This account should guarantee that, until the latest years of his life, Leonardo has got a portrait, never delivered to his patron, although one needs to trust that the portrait of «certain Florentine woman» was just that of Mona Lisa Gherardini.

Needless to say, the brief notations by de' Beatis, rather than offering some certainty, have done nothing but divide the scholars and concurred to further deepen the mystery of the Louvre woman. Two observations, however, in my opinion, have to be expressed in favor of the hypothesis identifying the portait described by de' Beatis with the *Mona Lisa*: the first concerns the fact that she would be an almost unknown woman («certain Florentine woman»), which matches with the social position of scarce importance played by the wife of a silk merchant such as Francesco del Giocondo (although he charged some rather important public office, as well as many members of his family[12]), and denies that the sitter was a famous dame, such as Isabella d'Este, Constance d'Avalos or Caterina Sforza[13], as was also proposed for *Mona Lisa*. The second remark is that the painting was seen by de' Beatis *«perfettissima»*, i.e., accomplished, contradicting the «imperfection» attributed by Vasari with which Leonardo left it: thus this is confirming my (and by others) suspicion that, as already noted, the biographer drew from a description corresponding to an intermediate level of its execution, while the landscape was entirely missing, and that neither Vasari nor others around him (including the same members of del Giocondo family), had no idea how the portrait actually were disclosed in the Fontainbleau's paintings gallery.

The note given by the cardinal's secretary concerning Giuliano de' Medici as the patron (*«ad instantiam»*, i.e., «at the behest») of the painting, which must be considered authentically expressed by Leonardo at the presence of his guests aroused a lot of arguments. The explanations provided by the scholars, of course, are so many that giving an account of them here would appear a useless exercise of erudition, far from my purpose. In this regard, however, I rely a suggestion by Walter Isaacson[14], certainly not isolated, according to which it would have been

Giuliano de' 'Medici to induce Leonardo, during his permanence in Rome, between September 1513 and the autumn of 1516 or the spring of 1517 – the exact date of his latest transfer to France is controversial, whether before or after the winter to undertake the crossing through Alpine passes, but certainly subsequent the death of his patron, which occurred March 17, 1516, just a year after his marriage with Filiberta di Savoia –, to complete the formerly «*imperfetto*» (unfinished) portrait. This would explain the affirmation of Leonardo, mentioned by de' Beatis, about the «*instantia*» of Giuliano concerning the painting of *Gioconda*, as if the duke had been a sort of its 'second client'.

Leonardo could hardly have transformed yet the already impressed face of Lisa Gherardini into that of a former lover of the duke, such Pacifica Brandani (or Brandano), who died by the consequences of the birth of their natural child (Hippolytus, future cardinal), as Carlo Pedretti and some other scholars have instead hypothesized[15]. It is against this hypothesis the occurrence that Brandani was from Urbino, thus certainly not a «Florentine woman», as de' Beatis reports; moreover, Leonardo did not personally know Brandani and certainly counterfeiting the Lisa Gherardini's face, real or ideal, with the physiognomy of another woman could hardly justify and promote a 'second commission' by Giuliano to honor his beloved's memory. Anyway, the radiographs published by Hours in 1954 and the late reflectographic tests did not provide the absolute evidence that underneath the guise of *Mona Lisa* there are hidden other faces.

The de' Beatis' *affaire* would thus close with a further point in favor to the traditional identification of Lisa Gherardini as the woman represented by Leonardo, since the remarks written by the secretary of Cardinal d'Aragona are congruent with the account referred by Vasari and, on the contrary, they provide further details. But it does not clarify the reasons for the posses-

sion of the portrait still in the hands of its painter, while, as it would be in the rules due to its typology, it should have been handed over to its clients.

Keeping on the analysis of documentary evidences, the note written (around 1540) by Anonimo Gaddiano around Leonardo's *Mona Lisa* proves that during the first decades of the sixteenth century in Florence was spreading many contradictory and confused accounts and memories about the commission of the painting and the sitter depicted in it[16]:

> *Leonardo son of ser Piero da Vinci Florentine citizen [...] He portrayed from the real Piero Francesco del Giocondo*

Since there is no news of such a commission and certainly is only known the existence of a Piero del Giocondo as the first born (25 May 1495-28 February 1569) by Francesco and Lisa Gherardini[17] and of no Piero Francesco del Giocondo, some scholars are not bent to give much credit to this account, due to the evident misunderstandings that are shown among the del Giocondo family relatives. Otherwise we must admit, given the typical synthetic structure of the personal notes, the lack of some words that would complete the sentence, such as: «*he portrayed to the real* [the mother of] *Piero* [of] *Francesco del Giocondo*». Zöllner, not without some reason, supposes instead that Piero del Giocondo was simply the informative source of the anonymous writer, though it proves that he took the report in a confused way[18].

A few of people knows that the *Gioconda* nickname was linked to the name of Lisa Gherardini in rather late times and that it appears for the first time only in private accounting documents, which are intertwined with the matter related to the troubled inheritance of Leonardo and to the painting's acquisi-

tion into the royal french collection. If de' Beatis' diary informs that they were into the *atelier* of Leonardo in the residence of Clos Lucé the three masterpieces now collected in the Louvre – the *Virgin with Child and St. Anne*, *St. John the Baptist* and the alleged *Mona Lisa* – in October 1517, then it is probable that just to these three paintings refers a payment entry noted between 1517 and 1518 by Jehan Groiler, treasurer of King Francis I, in favor of Salaì due to the selling of unspecified paintings, at the remarkable amount of two thousand six hundred four *livres tournoises*, three *sols* and four *deniers*[19]:

A messire Salay de Pietredorain [Salaì di Pietro d'Oreno], *paintre, pour quelques tables de paintures qu'il a baillées au Roi, Iim,Vic, IIII l.t. IIIs IIIId.*

So one could argue that Caprotti, before leaving Leonardo, seriously ill, was charged to sell – he could hardly manage the sale by personal initiative in front of the king's officers while Leonardo was still alive, unless a formidable deception[20] – the paintings left in his master's studio, presumably including the wooden panel of *Mona Lisa*. This would explain why no mention is made of them in the will drawn up by Leonardo on 23 April 1519 at the presence of the notary Guillaume Boreau, which benefited the pupil Francesco Melzi for all his own folios, books, drawings, clothing and even the royal income, without specifying anything else about the paintings. But also why Salaì inherited a marginal part of his assets, consisting in a half of the vineyard granted by Ludovico il Moro, which Caprotti was already owned and where he had built the house where he retired hereafter his return to Italy, whereas the other half of the same estate was donated to another attendant, Battista de Villanis. Perhaps the «*servidore*» (servant) Salaì gained from Leonardo the

17

entire proceeds by the paintings sell as personal compensation for his «*boni et grati servitii*» (kind and appreciate services)[21], before consensually leaving his teacher and companion of many adventures and avoid seeing him die infirm? According to my opinion and by other scholars, this would seem to be the most likely hypothesis[22].

Actually in the years after his return to Lombardy, Caprotti led a very wealthy life (he had also previously withdrawn by himself the wealth stored into the Vincian's account in Milan, amounting to 1,250 *scudi*), so much to get married soon, exercise the money loan and afford precious clothes and jewelry[23]. This wealth is proved by the inventory of his inheritances written in duplicate in 1525 following his death, which occurred on January 19, 1524 for a shot fired by a French military, perhaps on behalf of his two sisters Angelina and Laurenziola and the widow, Bianca di Annone. In it we realize a list of twelve paintings owned in his house, among which we highlight, in the *extensa* copy, a[24]

Quadro de una dona aretrata n.° 1 sc. –;l. – s. – d. –
Quadro [in the margin] *dicto la Joconda* ~~dicto~~ sc. *100; l. 505, s.*
~~la Honda C°~~ [strikethrough] *n.° 1* – d. –

Thus here is the first time that appears the diction *Joconda* (*Gioconda*, contracted in the same note in *Honda*, according to the Tuscan phonetics, then corrected with a stroke of pen) that traditionally refers to the portrait of Lisa del Giocondo. I do not believe the word *Honda* deserves a great relevance, because it never recurs in other documents and even in this occurrence it appears to be transmitted as an error. The hypothesis linking its initial letter to the «H» that appears on the back of the Louvre panel, suggested by Cécile Scailliérez, does not seem worthy of

great consideration. On the contrary, I am persuaded that this letter, which shows a five-seventeenth-century handwriting, has been impressed by Italian or French notary officials for the mere inventarial purpose; much less I believe that it points out the sense of vertical disposition ('h' as *haupt*)[25].

You note that all paintings included in the inventory of 1525 attained at that time a very high rating, equal to one hundred *scudi* each (two hundred for *Leda* alone) and a total of 1,590 imperial livres, but these very high estimates were perhaps affected by the boastings spread out by Salaì when he was still alive or by a plot staged by his sisters[26]. A Vasari's statement remarks that there was a great confusion between Leonardo's original samples and the copies painted by Caprotti or other students, and that it had given rise to many hearsay[27]:

> [...]*and certain works still in Milan, and said to be by Salai, were retouched by Leonardo himself.*

In fact, in a subsequent evaluation of the collection, compiled in 1531 due to a debt contracted by Lorenziola Caprotti with such Girolamo da Sormano, the estimate of all the paintings, which amounted at nine, including a «*Ioconde figuram*», got the value of 26 *scudi*, equal to 241 imperial *livres*[28]. I agree with those scholars who, even because of this notable depreciation, suggest that it would be a group of copies by Leonardesque original samples performed by his pupils – actually, if you scroll latter list you will notice at least two images of St. Jerome and two of St. John – that Salaì owned in that family house (the building already settled on the vineyard donated by the Moor to Leonardo), and recognized as not authentic at that time (perhaps due to the acquisition of certain informations about the real location of the original paintings) and therefore evaluated more carefully

than the previous estimate.

These different lists show that even after the death of his Master and during his last stay in Milan, between May 1519 and the tragic 1524, Salaì never stopped painting and reproducing Leonardesque models, an occupation in which, according to what the criticism attributes to him, he could boast an indisputable primacy, thanks to his skills acquired through thirty years of experience beside Leonardo himself. Anyway, the presence of a picture of a «Christ at the column, incomplete» («*Cr[ist]o a la cologna no[n] formado*»), in both the lists of his hereditary inventory in 1525, proves the unceasing activity by Caprotti as an autonomous painter as well as a copyist[29].

All this lets me think that even the *Joconda* owned by Caprotti that appears in the lists of 1525 and 1531 was one of the many copies of the original masterpiece of *Mona Lisa* that, to be fair, it might have been already bought due to the aforementioned arrangement with the French king's treasurer, in 1517-18, as suggested by Bernard Jestaz, who published the accounting document relating to its purchase-sale[30].

It seems to me that in the misunderstandings caused by the circulating copies and the various widespread nicknames to indicate the same portrait, perhaps already become a 'genre' of painting also due to the elaborations done by the Vincian's pupils, also Lomazzo fell, where, in his *Trattato dell'arte della pittura* (1584), he referred to Leonardo two different portraits, one of *Monna Lisa* and the other of such a *Gioconda*[31]:

> [...]*amongst the portraits made by the excellent painters [...] one can see those by Leonardo's hand, in guise of the spring, like the portrait of the Gioconda and Mona Lisa, in which he expressed, among other things, wonderfully the laughing mouth.*

Perhaps, as Marani, Kemp and Pallanti authoritatively observe, it would be a misprint that caused the replacement of the conjunction «and» (in italian: «e») instead of a «or» (in italian: «o») to describe the same picture; the error is also shown by the fact that the sentence refers to the singular («like the *portrait* ...») and not to the plural as it would have been correct if there would have been two separate paintings[32]. It does not seem believable, however, that Lomazzo had ever seen the panel at Fontainebleau, nor that he nevertheless had got well-informed sources, or understood them well, because in one of his later, and much more famous, book, the *Idea of the Temple of Painting* (1590) argues contradicting the Neapolitan origin of the sitter portrayed in the so-called *Mona Lisa*[33]:

Whoever desires to see them [excellence and perfection, rev. by Author] *in painting, looks at the finished works, (though they are few) by Leonardo da Vinci, like the nude Leda, and the portrait of Neapolitan Mona Lisa which are in Fontainebleau in France, and will know how much painting exceeds, and how much more powerful it is in attracting to itself the devotees' eyes, than nature itself.*

This indication has, of course, led some scholars, including Carlo Vecce[34], to propose a different identification, though nowadays it appears rather lapsed, of the *Mona Lisa* sitter not as Lisa Gherardini but as such Isabella Gualanda (or Gualandi), a Pisan dame born in Naples, whose beauty was known and appreciated even by the de' Beatis, who perhaps Giuliano de' Medici met when the painter was living in Rome[35]. The result is that the remarks provided by Lomazzo helped to further deepen the 'mystery' of the Louvre's lady.

The definitive assimilation of the portrait of *Monna Lisa* with what is known under the name of *Gioconda* occurred only in the

seventeenth century, thanks to some commentators and journeyers; first of all the authoritative Cassiano dal Pozzo who, visiting in 1625 the Fontainebleau castle jointly to the cortege of Cardinal Francesco Barberini – curious analogy with the visit of Antonio de' Beatis – recalls in his notes[36]:

> *At the Chateau of Fontainebleau is a portrait at life size on wood in a carved frame of a half-length figure and it is a portrait of a certain Gioconda. This is the most complete work be Leonardo da Vinci to be seen, since it lacks nothing but speech. [...] The head is adorned with a simple hairstyle, but nevertheless very fine. The dress displays a black or dark brown colour, but it has been so badly served be varnish that it can no longer be clearly be discerned. The hands are beautiful and, overall, despite the bad treatment this painting has suffered, the face and hands manifest such beauty that they enchant all who see them. We noted that the lady for all her beauty is rather lacking eyelashed, which the painter has not made evident, as if she did not have them.*

There are many questions that this report raises. Leaving out the academic ones, two in particular I would like to point out to be useful to our subject. The first is that Cassiano dal Pozzo declares the portrait absolutely complete, indeed «the most complete» among Leonardo's works, denying, as already noted, Vasari on the alleged «imperfection» of the painting, but confirming the hypothesis that the biographer from Arezzo has relied on an information source related to an intermediate stage of its execution. The second concerns the matter about the conservation and tampering of the painting: the overlapping by «varnish», moreover given in a «battered» way, and the «misfortunes» declared by the visitor, recall all interventions on the painting that occurred over time and caused the opacification of its colors, the yellow-brown *patina* that altered their original composition, the evident *craquelérie*, and certainly the reason for the

loss of some layers of thin colour veils that Leonardo had laid out during the long processing time. It is believed that the cleaning and overpainting actions, compromising the most superficial layers, would have erased the eyebrows described by Vasari, whose minimal traces were discovered by the high-resolution scans conducted by Pascal Cotte in 2007[37] and, in my opinion, appear even in the first radiograph made in 1927, as a thin line of very sparse hair[38]. To the same deplorable former cleaning actions – those in 1809 were remarkably destructive – should be referred the loss of other elements placed in the most superficial colour layers, such as, for example, the blush into the cheeks and lips as described by Vasari, the «leonine» effect of the dress noticed by Cassiano dal Pozzo, but also the details that would have better outlined the balcony with its two side columns, the balustrade, and even the seat. These manumissions might have also caused the loss of the wedding ring that was supposed wearing the alleged wife of Francesco del Giocondo, although, as many authors have observed, it does not even appears among the many copies – as we shall see – of this painting, so nothing forbids to think that the absence of the wedding sign was consciously produced by Leonardo himself.

Almost contemporary of Cassiano dal Pozzo, father Pierre Dan, prior of the Fontainebleau monastery, has transmitted to us the first clear correspondence between the *Monna Lisa* vasarian entitling and the equivalent term of *Gioconda*, unifying these two denominations into the same portrait held in the royal collections at that moment. His account proves that the acquisition of the painting took place through a regular sale, hired by Francis I with an unspecified counterpart, which closed with the payment of twelve thousand francs[39]:

Chapter one

> *The fifth in number and first in value, as a wonder of Painting, is the portrait of a virtuous Italian lady, and not of a courtesan (as some believe), called Monna Lisa, vulgarly called Gioconda, who was wife of a Ferrarese man named Francesco del Giocondo, a close friend of Leonardo, whom he had allowed to depict the portrait of his wife. The great king Francis bought this table for twelve thousand francs.*

The almost fictional remarks about the friendship between Leonardo and Francesco del Giocondo that are not documented at all – is supposed a vague mutual acquaintance thanks to Leonardo's father, ser Piero, who has drew up some notarial acts for Francesco del Giocondo, and because of their common attendance to the Holy Annunziata church[40] – and the inaccuracies concerning the client's origin from Ferrara, as well as the courtly context of Father Dan's account, in some way invalidate the reliability of this testimony, with particular reference to the details of the sale, which, therefore, can not be assumed entirely.

With the same criteria we should not rely the recall reported in 1666 by André Félibien about an occurred transaction that would get the portrait of Lisa Gherardini into the Fontainebleau royal collection for four thousand *écus*[41].

Despite all the doubts due to the case, however, the sense of these testimonies remains, which, in my opinion, endorses the aforementioned note of payment in favor of Salaì in 1517-18 as the act by which the portrait *de facto* was brought into the king of France's painting gallery.

Regarding the time of his definitive placement in the Fontainebleau castle, Frank Zöllner recalls a remark by Abbé Guilbert in 1731[42] which assures that *Monna Lisa* was set in the *Salle des Bains* of Fontainebleau as early as 1542, jointly with other paintings by Italian masters. Although no inventory nor other act endorse the belated remark recalled by the abbot, this informa-

tion appears to be consistent with what transmitted by Vasari – the biographer wrote his book around 1547, though the first edition of his *Lives* was published in 1550 – so it can be taken as reliable to establish the date of placement in the gallery of the royal maison.

Yet actually all these documents do not explain completely and unequivocally what occurred around the *Gioconda*'s acquisition by king of France. Paradoxically, for the most famous and studied painting in the world, only the Leonardo's unmistakable painting technique, due to its drafting of several very thin layers of colours, gradually brightening from the dark background, that defines the 'sfumato' and the 'aerial perspective', ensures that the painting saved in the Louvre is the original portrait of *Mona Lisa* and not one of its several copies depicted by pupils, perhaps come into the King of France's property given a deceit arranged by the mocking Salaì. But, having to do with the *Gioconda*, one can never say that things did not go just that way.

Which landscape?

The whole *Gioconda*'s mystery has got a double profile. On the one hand, one come from the depicted woman, on the other, one from the landscape. At first glance, anyone clearly catches that this painting should be not a real portrait, due to the originality of his background that has no equal in comparison with suchlike pictures. Nor comparing it with all the other portraits painted authentically by Leonardo, in which a unitary background highlights the sitter in the foreground. The scenary behind *Mona Lisa* is perceived, instead, not as a filling artifice, a subordinate accompaniment to the human figure that holds its

figurative primacy, as in whole coeval Italian and Flemish portraiture, but as an integral part of the composition, intimately connected to the sitter, and merged to the woman through the delicate colour veils and the shadowing outcomes of the so-called 'sfumato' .

The differences against coeval portraiture one clearly catches also in comparison with those contemporary portraits painted by Raphael that scholars relate unanimously to the pattern of the *Gioconda*, which he almost certainly saw in Florence around 1505. They are so evident taking account the portraits of Agnolo and Maddalena Doni (circa 1505) and, above all, the drawing, today in the Louvre, for a female portrait (1504-5, inv. 3882; **FIG. 1**), from which come his *Lady with the unicorn* (ROME, *Galleria Borghese*; about 1506): in these pictures the direct inspiration from the *Gioconda* appears fully clear, both for the compositional structure that showcases the two side balcony columns, which have almost disappeared in the Louvre panel – but not in the early copies, so much so that it is thought that the supposed side mutilation, equal to almost one centimeter per side, which also brings a slight a-symmetry, occurred after its arrival in France[43] – and for the 'counterposed' (*contrapposto*) of the figure. The difference between them concerns in the landscape, which in Raffaello's portraits appears completely subordinated to the prominence of the sitter: the low horizon, almost half of the field of vision as requires a good compositional rule, clearly reduces the presence

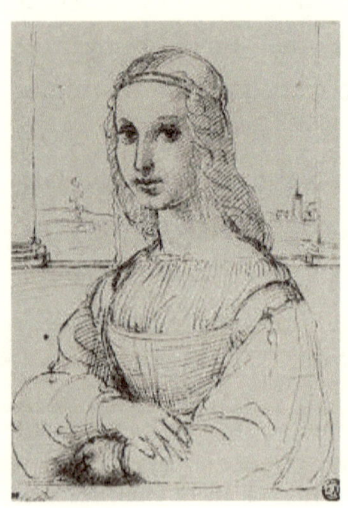

FIG. 1

of the scenary and places the woman's face within a compact space of blue sky, arousing the same subordination of the background with respect to the figure, an isolation and detachment between them that can be compared to the unitary color fields implemented in other portraits, as, for example, in the so-called *Gravida* (Florence, Palazzo Pitti; 1506) or in the *Muta* (Urbino, Ducal palace, 1507), which rather appear much closer to the Leonardesque samples such as the *Belle Ferronière* (Lucrezia Crivelli) or the *Lady with an ermine* (Cecilia Gallerani), and to the traditional Italian portraiture.

The *Gioconda*'s composition is atypical also in comparison with every Leonardo's portraits. In his Milanese ones he demonstrates that he was fully aware of how to balance the relationship between the figure and the background, through the brightness of the foreground and the choice of a unitarian dark coloured background to highlight the sitter's physiognomy and seize its psychology.

So even in the case of the early *Portrait of Ginevra Benci* (Washinghton, National gallery of Art, 1475), the only painting comparable to the *Gioconda* due to the presence of a landscape, the woman's face is surrounded by a dark junipers large expanse that enhances the glow of her face and creates an isolation result, similar to the unitary backgrounds of the other Vincian's portraits. For the pre-eminence of the face, there is not in this juvenile portrait enough space for an airy landscape like that of the *Gioconda*, so that the scenary features are reduced to a lively blue sky outline around the mass of juniper foliage and a narrow gash, at both the side of the woman, that do not hinder the dark background on which the sitter's face shines brightly.

Leonardo was aware of the mutual influence amongst the colours and of the results determined by their combination to the observer's eyes, so that their disposition could not be causal,

nor determined by preconceived models, but each time well juxtaposed[44]:

> *Chap. CCLV – On the Back-ground of Figures.*
>
> *Of two objects equally light, one will appear less so if seen upon a whiter ground; and, on the contrary, it will appear a great deal lighter if upon a space of a darker shade. So flesh colour will apper a pale upon a red ground, and a pale colour will appear redder upon a yellow ground. In short, colours will appear what thay are not, according to the ground which sourrands them.*

The critical 'discovery' of the *Mona Lisa* landscape is queerly recent; ignored completely by Vasari, who drew, as seen, from sources relating to a draft which was limited to the «head», and by the other successive commentators, formed on the conceptual prejudice of the primacy of the *humanitas*, it is due only thanks to the development of romantic taste for Nature. Walter Pater became the spokesman of this discovery in the *Mona Lisa* for the first time, when, realizing the inseparable unity between sitter and background, he stated in 1869[45]:

> *What was the relationship of a living Florentine to this creature of his thought? By what strange affinities had the dream and the person grown up thus apart, and yet so closely together? Present from the first incorporeally in Leonardo's brain, dimly traced in the designs of Verrocchio, she is found present at last in* Il Giocondo's *house. That there is much of mere portraiture in the picture is attested by the legend that by artificial means, the presence of mimes and flute-players, that subtle expression was protracted on the face. Again, was it in four years and by renewed labour never really completed, or in four months and as by stroke of magic, that the image was projected?*
>
> *The presence that thus rose so strangely beside the waters, is expressive of what in the ways of a thousand years men had come to desire. Hers is the head upon which all "the ends of the world are come", and*

the eyelids are a little weary. It is a beauty wrought out from within upon the flesh, the deposit, little cell by cell, of strange thoughts and fantastic reveries and exquisite passions. Set it for a moment beside one of those white Greek goddesses or beautiful women of antiquity, and how would they be troubled by this beauty, into which the soul with all its maladies has passed! All the thoughts and experience of the world have etched and moulded there, in that which they have of power to refine and make expressive the outward form, the animalism of Greece, the lust of Rome, the mysticism of the middle age with its spiritual ambition and imaginative loves, the return of the Pagan world, the sins of the Borgias. She is older than the rocks among which she sits; like the vampire, she has been dead many times, and learned the secrets of the grave; and has been a diver in deep seas, and keeps their fallen day about her; and trafficked for strange webs with Eastern merchants: and, as Leda, was the mother of Helen of Troy, and, as Saint Anne, the mother of Mary; and all this has been to her but as the sound of lyres and flutes, and lives only in the delicacy with which it has moulded the changing lineaments, and tinged the eyelids and the hands. The fancy of a perpetual life, sweeping together ten thousand experiences, is an old one; and modern philosophy has conceived the idea of humanity as wrought upon by, and summing up in itself, all modes of thought and life. Certainly Lady Lisa might stand as the embodiment of the old fancy, the symbol of the modern idea.

Pater's suggestions have paved the way for a new critical position toward the *Gioconda*'s landscape and the recognition of a inner dynamic between the figure and the background that more and more often today is considered as an expression of a conceptual relationship linking them. Thanks to this connection no one can now think of *Gioconda* without considering it as an entirety of *figure and landscape*.

From the last nineteenth century onwards, the blossoming of studies that involved the landscape behind the *Gioconda* did not cease, although, as well as about the sitter, these efforts did not lead to a shared opinion. Thus, the more the critical analyzes on

the features of the Leonardesque landscapes carried out, the more their oddity emerged, then the more the 'mystery' of the painting grew.

I suggest to mind the Louvre *Gioconda* landscape divided vertically into two parts, on the right and left of the sitter, being the horizon line – not straight, or almost concave, anyway very high, as if the loggia is overlooking from an high-altitude refuge – not coincident in them, as if Leonardo had intentionally split the sight into two different scenes, albeit analogous. In both sides, however, the same landscaping elements are noticed: beginning from the top, there are impervious mountains, peaks and dolomites, much sharp on the right side (with respect to the observer), where clouds and vapors also appear; further below, are depicted two water lochs, almost an alpine high altitude lake on the right side and, on the left, a placid large lake, set between the mountain heights like Lombard pre-Alps. Divided from them by other lower mountain ranges, to the left, and by the ridges of badlands to the right, serpentines narrow rivulets appear flowing trough the former, and the loops of a large river stream close to the hair of *Mona Lisa* through the latter, up to both are losing themselves behind the profile of the loggia's balustrade. Curiously we can not notice any woods, or vegetation, or living beings (apart from the same woman) that animate this view, that is composed, we observe for the moment, only by atmospheric and inorganic items: water, vapors, rocks, soil. The only foreign presence to this almost primordial nature is the shape of a four spans bridge, wading the sinuous river, that is depicted just above the left shoulder of the woman (to our right).

It is not for a long time that criticism has moved to identify the place (or places) depicted by Leonardo in this scenary in the attempt, as in the case of the female figure, to 'give a name' to

this landscape. As if the identification of an exact site resolved the question of the meaning of this painting. Quite suitable, however, is the hypothesis of identifying the ancient thirteenth-century bridge of Buriano over Arno river and the scenery surrounding it near Quarrata and Arezzo, rather than the Montefeltro places, as it has been recently hypothesized[46]; more arduous is the identification of precise places for the rest of the panorama, which seems to be made up by 'separately quoted' fragments of high Valtellina alpine landscapes, and Lombardian lakes, jointly with the typical Apennine geomorphology with its ravines and wide valleys. Taking into account just these few elements one realizes that the *Gioconda*'s landscape is totally a-typical with respect to the conventional views depicted by Flemings or Italians. I guess, agreeing with Vecce and others[47], that Leonardo conceived in this case a sort of ideal synthesis of his own 'memory places' or 'experience places', almost a montage of photography shots ranging through the remembrance of his own living, from his hometown sites to the Apennine valleys crossed following Cesare Borgia (1475 ca-1507), from the alpine valleys near Como he visited as hydraulic engineer for Ludovico Sforza to the karstic marls surveyed to plan the defense of Venice against the Turks.

This very personal compositional *formula*, which could be assessed as the point of maximum evolution of the Vincian's research about the landscape painting, had taken its first steps since his early juvenile explorations on this theme. When dealing with the *Gioconda* landscape it is not uncommon to find out in the critical literature some comparisons with drawings, phrases and observations spread in Leonardesque codes recalling fragments of his lived experience and, in particular, the emphasis is placed on a drawing performed by a very young Leonardo[48] – the date shown marks August 5, 1473 – which shots the Arno

valley's panorama from Monsummano to Fucecchio from the top of the Montalbano peak. This is not a realistic tracing in the proper sense of the word, almost like a postcard, but rather a synthetic transposition of distinct drawing 'snaps' taken from an aerial point of view, comparable to the outcome of a wide-angle or a flying camera. A «synthetic approach», similar to a «cinematographic roundup», using a fine expression by Carlo Pedretti[49], which creates the impression of a territorial panopticon.

Sometimes a Leonardo's description about two lakes that Arno river makes up between Florence and Arezzo was stressed, which some scholars believe have been reproduced in the *Gioconda*'s upper part[50]:

> [...] *in the great Arno's valley, above the Golfolina, a peak from the antiquity joined to the Monte Albano like a very high embankment which kept the river engorged, so that, before pouring into the see, it creates two large lakes, of which the first is the one that today is enjoying the city of Florence, together with Prato and Pistoia [...]; from the upper Valdarno as far as Arezzo a second lake was created, which in the aforesaid lake is pouring its waters, closed around where today we see Girone, and it occupied all the aforementioned upper valley as long as forty miles in length.*

But, as also Martin Kemp suggests, the two lakes of the *Gioconda*'s landscape do not match in the least what described by Leonardo, involved, instead, to «recreate the nature»[51], that is to expose a synthesis of the topographic elements arranging a panorama on a territorial scale.

Another drawing that has rose up some comparison, I would state 'typological', with the right side (with respect to the observer) of the *Gioconda*'s landscape, is a sketch of a thunderstorm into an alpine valley with a lake and an urban settlement (WINDSOR, *Royal Library*, f. 12049r) – perhaps taken by Leonar-

do from a mountain village in Veneto or Friuli during his engagement for the Venetian government and, for this reason, it dates to around 1500[52] –: it can be minded as an example of his meditations about atmospheric agents and meteorological phenomena, in particular those related to water and its power to mark the earth's metamorphism, which will follow the Vincian throughout his life, up to their climax into the *Leicester codex* (1506-1510, nowadays owned by Bill Gates) and his famous *Deluges*' drawings. Yet even in this case the comparison between this realistic view with the *Gioconda*'s 'primordial' landscape does not lead to any unquestioned result.

Let us now go back to the case of the landscape behind the *Mona Lisa* sitter, because, beyond the slack correspondences that can be claimed with the Leonardesque drawings, on which I would not insist too much, especially taking in mind that, despite the long painting time, there are not any drafts in his codes related to the iconographic features of the *Mona Lisa* – though we know only a fifth of the whole *corpus* of his manuscripts survived – everything could be said except that it is a realistic depiction and that Leonardo wanted to resume a very exact site. On the other hand, it appears clear that the landscape conceived by Leonardo unfolds to be atypical even comparing to the mostly conventional models of the both Italian and Flemish pictorial tradition, which howsoever tends to retain the naturalistic features of a real vision. The scenario where *Monna Lisa* is plunged would remain into the medieval or Renaissance Italian or Flemish traditional pattern of 'bird's eye view', if it were not that, even starting from the very juvenile first landscape drawing, Leonardo did not had catched the role of atmospheric elements, elaborating the so-called 'aerial perspective': the air and the fog, conceived as the moist breath of the earth, with their gradual attendance, change the shape and color of eve-

rythings, according to their distance from observer, and arrange the depth of the infinite visual field. This utter originality distinguishes Leonardo's landscapes from the works of his youth, as declare the views on backside of his angels within the Verrocchio's *Baptism of Christ* and in his own *Annunciation*, up to those of his maturity, just as in the *Madonna dei Fusi* and the *Gioconda*.

The feeling increasingly sustained, especially by the scholars from the second post-war who have engaged the matter about the landscape of *Gioconda*, is that the long draft of the painting has led Leonardo, as in the case of the Lisa Gherardini's face, to conceive *also* this view transcending the reality to get on the ideal, or, better still, metaphorical level. This critical point, however, did not lead to the univocal and shared recognition about the content, the subject, on which Leonardo would have built his allegory. Definitely the declaration by Kenneth Clark on the meaning of a Leonardo landscaping representation as «part of an immense machine», alike a human being[53], – I would add: the functioning and the apparatuses of a living Nature conceived as an huge organism – has offered an excellent contribution to the cognizance also of the *Gioconda* naturalistic scenery. From this point, the hypothesis that nowadays is supported by a great number of scholars, unless those are misleading into the boring fanciful topics, recognizes among the sitter and the background an analogical relationship within the dialectic, typically Renaissance, between microcosm and macrocosm[54].

Among all fair arguments that would explain the meaning of this analogy, especially those referring to cosmology, philosophy, scientific naturalism, it seems to me useful to recall the point suggested by Martin Kemp[55], according to which the *Gioconda* would gather the Leonardesque meditations about the 'body of the Earth', that is the equivalence between the physiology of the human microcosm (according to Leonardo «*homo* is

called by the ancients the minor world»[56]) and the geomorphology of the terrestrial macrocosm. The painter, actually, states many times there would be a strict correspondence between the shape and functioning of the 'human machine' and the structure and dynamics of Nature. It would not be so much a literary analogy or a rhetorical or poetic expedient, but a real correspondence that would help whoever to realize mutually the physical and physiological phenomena in their own functioning and in their analogous structural shape. This belief, Martin Kemp notices, was common thoughtout ancient philosophers and naturalists, among whom are included Ptolemy, Aristotle, Plato, and also Seneca who, in the third book of his *Naturales Quæstiones*, states[57]:

> *I like the idea that the earth is governed by nature and is very similar to the system of our body, in which we find both the veins (blood vessels) and the arteries (air vessels). In the earth there are some courses through which water flows, others through which air passes. And nature shapes these ways in a similar way to the human body, which even our ancestors called them «water veins» […]*

Since Leonardo even shows that he shared this ancient conceptual tradition, it is reasonable to suppose that it was acquired not directly from Anticians – it is known that he called himself «*omo sanza lettere*» ('a not literate man')[58], that is to say without the knowledge of the Latin language and the ancient texts –, but rather from medieval literary authors, including Dante (*Qæestio de aqua et terra*) and Brunetto Latini (*Li Livres dou Tresor*) [59], but above all from *La Composizione del Mondo con le sue cascioni* (*The earth's composition with its causes*, 1282) by Ristoro di Arezzo, who stated the same analogy between man-microcosm and creation-macrocosm that Leonardo often invokes in *Manuscript A* and in

the *Codex Leicester*. Though for this latter medieval author this sympathy should be held as a literary or metaphoric creation[60], it becomes for Leonardo the starting point for a material scientific experimentation that, carried out into the practical field of anatomical dissections and naturalistic studies, leads him to adopt this ancient assumption. Thanks to these experiences he deduces that between the mankind 'minor world' and the Earth's 'major world' there are very similar forms and processes[61]:

> *So that we might say that the earth has a spirit of growth; that its flesh is the soil, its bones are successive strata of the rocks which form the mountains, its muscles are the tufa stone, its blood the springs of it waters. The lake of blood that lies about the heart is the ocean; its breaking is by the increase and decrease of the blood in its pulses, and even so in the earth is the flow and ebb of the sea. And the heat of the spirit of the world is the fire which is spread throughout the earth; and the dwelling-place of its creative spirit is in the fires, which in divers parts of the earth breathed out in baths and sulphur mines, and in volcanoes, such as Mount Aetna in Sicily, and many other places.*

Leonardo believed that life in both 'worlds' is administered by the stream of fluids: as he attributes to the water the biotic maintenance of the «earth's machine»[62], to the rivers, the underground water tables, the lake and sea basins, the power to animate all the phenomena that rule any vital processes, so in the same way he suggested it would occur in the human and animals physiology through the body fluids, the blood, the veins, the arteries, the heart[63]:

> *The body of the earth, like the bodies of animals, is woven with branches of veins, which are all joined together, and are established as nourishment and vivification of the earth itself and its creatures, and branch off from the depths of the seas, and from those, after many roamings,*

they return to the rivers created by the breaking of these veins at high altitude.

At the base of this belief is Leonardo's recognition of a cosmos lived by a vital spirit or «vegetative soul», an animated Whole, in which phenomena reveal themselves in the universal and in particular in similar forms. In the mature *Codex Leicester* this *ratio* leads him to assign to the 'body of the Earth' the same processing dynamics of living beings, with their cycle of generation, development, decay and transformation[64].

Fundamental for this conceiving about the biotic and metamorphic nature of the Earth, it was for Leonardo the dealing with the fossils and his intuitions about the existence of geological stratifications as the result of the changes in the earth's crust. He relates himself in the *Codex Leicester* how, during his permanence in Milan, he was enticed to study the fossils after some peasants submitted him several specimens found in the Emilian Apennines[65]. Thanks to the surveys carried out in several places, Leonardo rejected the common explanation granting to the biblical Deluge (otherwise to extravagances by nature, or to metaphysical or alchemical processes) the cause for these formations, then he developed the idea that they were the result of extraordinary events due to the metamorphism of the earth that had arose surfaces formerly submerged down the seas. Thank to a topographical survey about the Arno and Adda river valleys and about the karst sinkholes, he realized how the earth surface is a ground subjected by ceaseless transformations, in which immense forces generating cataclysms, eruptions, earthquakes, seaquakes, are disclosed. In the *Codex Leicester*, Leonardo explains the origin of these changes by hypothesizing the collapse of the earth's external crust down into huge underground cavities filled by water, or air, or fire (in vulcanoes),

which caused massive mutations to the earth's morphology and the arrangement of the emerged oceans[66]. Moreover, believing the Aristotelian theory about the Elements' concentric spheres where the Water would be above to that of the Earth, he hypothesized that they were not perfectly spherical and concentric, so that this eccentricity, also helped by heating, would have been the origin of ocean huge movements and the emersion of the lands[67].

In some cases, Leonardo claims to the water's erosive and destructive action the metamorphosis of the ground and the shaping of valleys and plains; due to his experience as a hydraulic engineer for the Sforza, especially during his second stay in Milan (1508-13), and for the Florentine government during its war against Pisa, he also deepened his knowledge about fluid's dynamic behavior and understood its destructive and powerful strength, leaving us the results of his experiences and meditations in the pages of the *Codex Leicester* and in his extraordinary *Deluges*' drawings, now collected in Windsor Castle.

It is certainly fascinating to believe that, as Kemp suggests, the subject of the *Gioconda* were be a meditation about analogical relations and the metamorphic dynamics between the human body and the 'body of the earth', between the minor world and the major world, in brief, «a great metaphor about the universality of the human body in the context of the body of the world»[68]. This relationship would lead to match strictly the anatomical features of the sitter with the geological elements of the landscape, as if the former ones are extending into the background: a *formula* that was not at all extraneous to the Leonardesque painting, since the time of his youthful portrait for Ginevra Benci (the juniper plant alluding to her baptismal name), but which can be fully realized in the *Mona Lisa* by the meaning that Leonardo attributes to the term of 'comparison' in

his *Manuscript A* and *Codex Leicester*. This passage from *Manuscript A* seems almost exactly related to the Louvre panel[69]:

All the bodies together and each by themselves fill the surrounding air with its infinite similarities, which are all for the whole and all in the part, conveying with them the quality of the body, color and shape of their cause. Then all the bodies be similar to all in the surrounding air and all to the part, as body, shape and color.

The 'comparison' idea between the sitter and the landscape has often been involved by scholars to refer the analogy between the ondulated and curly woman's hair and the serpentine flow of the 'streams' close to her sides[70]. Why not then extend the same 'comparison' to all other elements of the composition? As well as the relationship between the hair and the two serpentine courses, I suggest that the cerebral cavities and ventricles would compare to the ridges and narrow mountain valleys; the two lakes to her eyes, which show – finally! – «the lustrous brightness and moisture» invoked by Vasari; the impalpable vapors, like the breath of the earth, which wrap up the landscape to her transparent veil covering the head and descending above the shoulders; the soft hills smoothed by the river flow to her cheeks and the very celebrated smile, her «so pleasing an expression» of the mouth, still remembered by Vasari, and so on.

Even if all this were only a metaphorical or compositional device, it would be enough to proclaim the incomparability of the *Gioconda* landscape to no one else ever painted before, perhaps the first one where the sitter's features extend and actually merge themselves in it: in short, I would dare to say that, more than a *paysage moralisé*, it would seem to be the first *conceptual landscape* of art history.

Chapter one

Mona Lisa and the others

Perhaps not everybody knows that there are some hundreds elaborations and copies of the *Gioconda* scattered around the world. Along the centuries preceding the invention of photography, the production of replicas was wholly usual and allowed to enjoy the most important works by the Masters of painting and to study them even in the most far places from the site of their location. Leonardo himself used to encourage his pupils to produce copies of his works and to provide even more elaborations by the same subject, from his *cartoni* (drafts) or directly from his paintings while he was producing them, sometimes jointing himself to the disciples during the execution of their own copies. For example, only for the *Madonna of the Yarnwinder*, at least a dozen versions are known which have seriously challenged the scholars to identify the original picture. Like this latter case, already when Leonardo was living some copies and personal interpretations of the *Gioconda* were depicted by his pupils – particularly curious are the versions of the so-called *Monna Vanna* or *Naked Mona Lisa*, whose at least one is painted by Salaì –, which multiplied even after the Master's death: it is supposed that around sixty specimens of the *Mona Lisa* portrait circulated only between the sixteenth and seventeenth centuries. The imitation went on incessantly throughout the eighteenth century and along the early nineteenth century, until the advent of photographic printing gradually overrun this practice; however, it is estimated that between 1851 and 1880 at least another seventy copies and studies were still painted[71]. A census conducted in 1952 on the known greater interesting reproductions counted sixty-one variants[72], though this number increased recently due to new discovers.

However, it should be noted that the numerous copies, due to the great uncertainties surrounding their origin and execution, and their indisputable differences compared to the portrait of the Louvre, if, on the one hand, helped certainly the scholars to study the original painting by offering them new clues, on the other they provided further issues to be solved about their realization that increase, as will be seen, the difficulty of wholly understanding the *Gioconda*'s 'phenomenon', and also widen the aura of 'mystery' of this portrait. However, comparisons amongst copies and the Louvre wooden panel allow to formulate some early meaningful deductions: a common *datum* is the absence of the wedding ring or other jewels recalling the bridal event or the sitter's social *status*; in all the copies the eyebrows are dotted with a thin line of hairs, the redness of the cheeks is always displayed, the framing with two columns sideward and the balustrade are nonetheless shown in a great relief. Therefore, we can deduce that, first of all, Leonardo has purposely dropped any reference to the personal and wedding *affairs* of Lisa Gherardini and any other element of contextualization, failing to the most usual purposes of portraiture. Secondly, the reliability of Vasari's testimony is greatly confirmed. I believe that the best contribution that the analysis of *Mona Lisa*'s most remarkable copies reserves for the solution of its alleged 'mystery' concerns the colors and the landscape features. To grasp the reasons for their importance, we should briefly deepen into the *affaire* of 'other *Mona Lisas*'.

Extraordinarily meaningful for my herewith assumptions is the copy of *Mona Lisa* collected now at the Prado Museum in Madrid. This painting, once conserved in the Mediodia Gallery of the Madrid Alcazar from 1666, where it came perhaps thank to Pompeo Leoni or as a consequence of the sack of Rome in 1527[73], before 2012 showed the bust of the alleged Lisa Ghe-

rardini perfectly alike to the Louvre painting, except for a greater thinness in her face, but surrounded by a compact background of dark color that however was the result of a showy overlap of paint over the original color layers. It was therefore decided to remove the repainting and what came to light is a landscape like to that of the Louvre, but with more bright co-

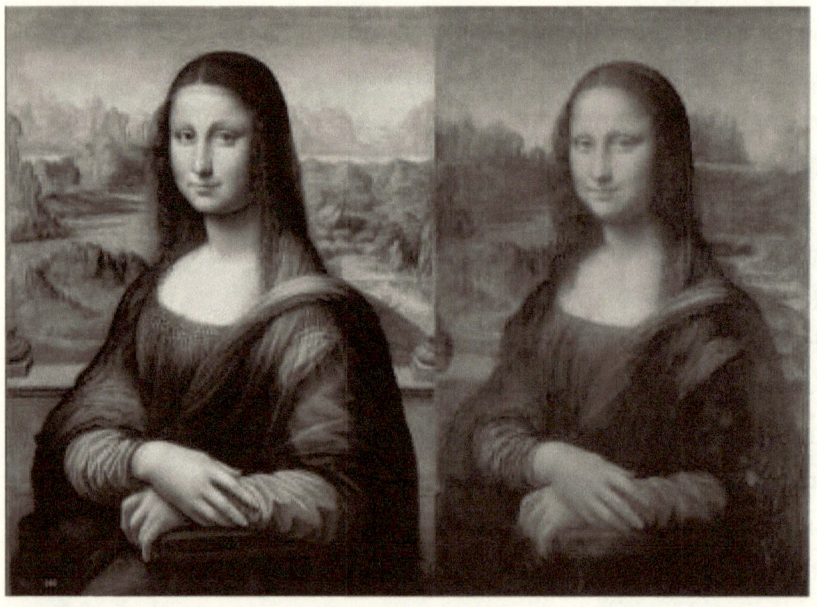

FIG. 2 – Comparison between the *Prado Gioconda* (left) and the Louvre *Mona Lisa* (right).

lours and more clear details.

Thanks to the cleaning of the whole surface, many features of the sitter's face, the dress, the veil and her garnitures now appear much more detailed than the Louvre original portrait: one finally appreciates the eyebrows, like a thin line of the same brown color of the hair, and that light pink color both in the cheeks and lips, which grant authority to the Vasari's informative source; finally, the sleeves of the dress show a bright red

vermilion. A lot of other details are clearly displayed, including those relating to the base of both the columns, the balustrade moldings and the chair's features. (**FIG. 2**).

The reflectographic tests carried out immediately in the Prado copy provided very interesting informations. The signs of an underlying design have emerged without transfer hints from *cartoni*; the figures show in every detail the same size in both the versions; signs of the same repentance, identical tweaks and corrections both in the original and in the copy, were discovered[74]. It also emerged in the Madrid copy that in the deeper colour layers, i.e., those laid out first, whereas the sitter is wholly shaped, only a small part of the landscape had been detailed: in its upper side rocks and lakes are missing and, in the section below the valley, the bridge and the river were not still depicted. Everything leads to believe that the copyist began to paint by observing the original from an intermediate stage of its execution, namely when only the *Mona Lisa* «head» was completed, but not entirely the surrounding landscape.

Kemp and Pallanti reasonably argue that the copying may have been undertaken from the beginning of the second Leonardo's stay in Milan (1508) or in Rome (1513), and it developed in parallel with the original, up to the fulfilment of the whole landscape. As evidence in favor of this hypothesis should be believed the choice of walnut for the Prado panel, instead of the poplar as in the Louvre original, which is the very favorite wood among the Lombard painters rather than Tuscanians, being this also the timber used by Leonardo in all the portraits he depicted during the Milanese period (*Portrait of a Musician, Lady with an Ermine, Belle Ferroniére*) and even prescribed by himself in *Manuscript* A[75]. It ought therefore be stated that the Prado copy was carried out in a very faithful and almost simultaneously manner during the slow drafting of the original Louvre

portrait: it involves one of Leonardo's closest pupil, though it does not rule out the straight attendance by the master himself.

These new clues support my belief, as will be seen, that the fulfillment of the *Gioconda*'s landscape ended in a different time from the «head», in a rather late period along the Vincian's artistic course, presumably from the time of his stay in Rome under the Giuliano de' Medici's *patronage* – a time strongly featured by his overwhelming interests into geological mutations, natural phenomena and atmospheric agents – till the years of his transfer to France. The name of Salaì that was suggested as the author of the Prado copy seems to me more reliable rather than that of Melzi, for biographical reasons – the noble pupil was actually too young and still inexperienced to carrying out such an excellent copy. It also appears congruent with the documentary evidences of Caprotti's inheritance, where, as we have already seen, a *Ioconda*, which probably should have been a different copy from the original previously sold to the treasurer of Francis I, is listed, so that it may be just the Prado *Mona Lisa*. Moreover, he was a ever kept in touch pupil with his master and therefore the only one able to enter every changes along the slack execution of this portrait; so, her thinner face and some details of the landscape and the dress, which are not completely executed with respect to Louvre model, can be accepted in view of Salaì's relatively mediocre technical skills the and the lenience which he enjoyed by Leonardo.

Although there are no absolute certainties, it is possible that the Prado copy shows very closely the real appearance of the Louvre *Mona Lisa* before the clumsy cleansers erased some colour layers and the protective paints yellowed the originals: in fact, rests of a bright blue sky, similar to that of the Madrid copy, emerge in the extreme upper edge of the Parisian wooden panel and in other points of the same area left out by ocher

paint. The consequences of the discoveries in the Prado copy rekindled the debate about the need to remove the opaque patina that hides the colours of Leonardo's original painting, but the risk of losing the delicate features of the '*sfumato*' around her famous smile and eyes discourages any intervention. Fortunately, to avoid this uncertain treatment contributes not only the Prado copy but also the digitized image that Pascal Cotte obtained in 2004, thanks to the adoption of a complex technique called LAM (Layer Amplification Method), which virtually gives us back what we might see finally after removing the varnishes that conceal the original *Gioconda*[76].

Some useful remarks, as we shall see, also reserve other replicas of the famous portrait, also notorious and discussed themselves, including the so-called *Isleworth Mona Lisa*, the *Mona Lisa of Saint-Petersburg* (or *Mona Lisa with columns*), the *Vernon Mona Lisa* and the *Mona Lisa Reynolds*.

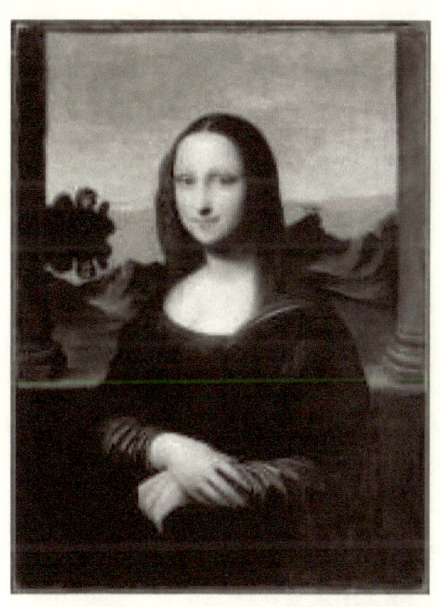

FIG. 3

The first copy was discovered in the early twentieth century in the manor of a Somerset nobleman and then bought and conducted to Isleworth near London by Hugh Blaker, an art collector, in 1914; acquired by the American magnate Henry Pulitzer in 1962, today it is kept in a Swiss bank's *caveau* on behalf of a group of tycoons who acquired its property[77]. The picture portraits the same woman into a very similar scenario to that reproduced by Raphael in the design of

Chapter one

the Louvre of 1504 and in his *Lady with the unicorn*. The *Mona Lisa Isleworth* (**FIG. 3**) shows very clearly the loggia's architectural details and the two side columns for almost half their width; the landscape is very similar to the Louvre original but only in the lower part, whereas the upper one is reduced to a large inland lake, on which a group of trees and some low peaks in the distance are mirroring. The very high alpine mountain ridges and the lakes are here missing, the horizon is very low and a wide space is opened into the sky, made up by a unitary background where the typical red-brown primer emerges, which Leonardo used to lay before overlapping the final colors, but it creates a fascinating twilight *nuance* that shines the bright complexion of the young woman. Traces of azurite and enamels springing up in the upper side let us to figure out how its unknown painter would have concluded the whole backdrop[78]. It should not be considered a complete work, so this remark would match Vasari's statements about a portrait of Lisa Gherardini left unfinished by Leonardo.

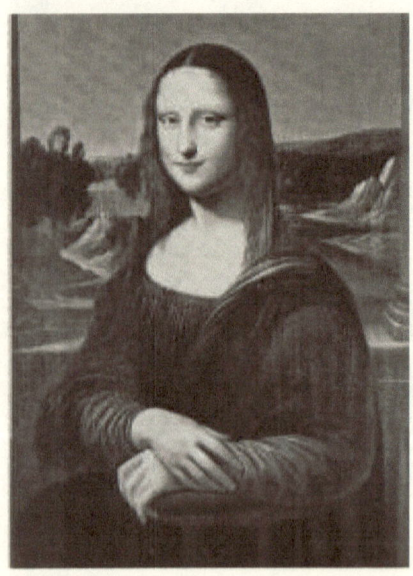

FIG. 4

For a better reading of the colours of this copy, and to hypothesize a possible ideal reconstruction of its complete features, it ought to deal with another version of the *Mona Lisa Isleworth*, the so-called *Oslo Mona Lisa* (Oslo National Gallery; **FIG. 4**), in which the landscape, definitely derived from the first, appears in a better chromatic condition, very alike to those of the Parisian portrait or the Prado replica.

A NOT-PORTRAIT

The *Mona Lisa Isleworth* is actually a puzzle for art historians. His pictorial *ductus*, extremely similar to that Leonardo owned, raises serious questions about his paternity, so much so that some critics have excluded it can be attributed to the hand of a pupil. The clues lead the experts of the *Mona Lisa Foundation* and other scholars to suggest the hypothesis that this would be the early original version, albeit unfinished, of the portrait of Lisa Gherardini, the same one copied by Raphael into the Louvre design, and depicted before Leonardo presumably changed his minds and undertook a new idealized portrait that later King of France purchased[79]. Actually, the painter was used to elaborate several versions of the same subject, leaving some unfinished, so it is worth calling to mind the judgment of the historian Paolo Giovio (1483ca-1552), Leonardo's first biographer, who in his *Dialogus de viris litteris illustribus*, emphasizes the fulfillment of just a few works, while others were only initiated and disused due to the his alleged natural impatience and fickleness[80]:

Sed dum in quærendis pluribus angustæ artis adminiculis morosius vacaret, paucissima opera, levitate ingenii, naturalique fastidio, repudiatis semper initiis absolvit.

The circulation of the so-called *Isleworth* version, perhaps known also thank to other copies such as that of Oslo, might have justified the Lomazzo declaration, already observed, according to which Leonardo would have painted a *Mona Lisa* and a *Gioconda*, suggesting the existence of at least two different models by the same subject.

The choice of canvas, which Leonardo did not ordinary used for his portraits, supports the thesis that it may be a copy by the hand of Salaì, or another disciple. However, since it is certain that even the Master carried out experiments in oil painting on

canvas, nothing denies the *Mona Lisa Isleworth* were performed by himself as a proof. One could actually observe that an eventual dissatisfaction, which would have led the painter to suspend the completion of the canvas and the return to the more usual wooden support for a second release of the portrait, matchs the Vasarian testimony regarding the alleged abandonment of the portrait.

The instrumental investigations, however, dated the execution of this copy at the beginning of the sixteenth century and ascertained that the applied pigments and amalgams are compatible with those of the Louvre *Gioconda*.

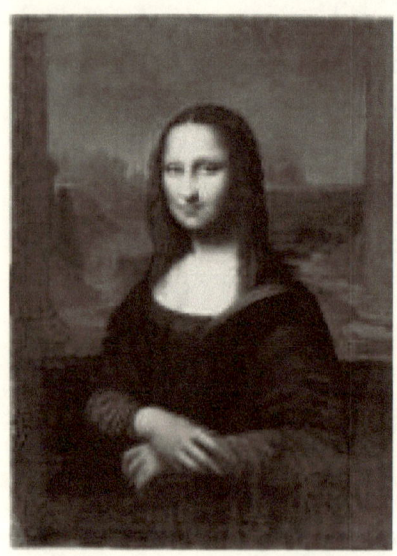

FIG. 5

The case of the *St. Petersburg Mona Lisa* (**FIG. 5**), owned by a private collection and kept at the Hermitage, seems to be almost solved. It is a work that perfectly reproduces the Louvre original with extraordinary fidelity and technical resemblance in every detail. Also in this case the side columns of the balcony are very detectable, the landscape colours are bright and qualitatively comparable as those of the Prado copy. However, the dating of the painting would be quite recent, as some scholars by University of Bologna demonstrated due to the presence of barium sulfate (baritin) discovered in the primer layer over this canvas, a substance that was used in the mixtures only among the parisian neighborhood between 1620 and 1680[81]. I would like to note that the choice of the canvas in this case, instead of the most

traditional and ancient use of wood that Leonardo himself advised, calls into question that the *Saint Petersburg Mona Lisa* may have been not painted during his time by his pupil or by himself. I therefore agree with those who believe that it is a perfect exercise copy carried out from real life in the Baroque age by an allegedly Flemish or French painter who had access to the royal collection. Admitting therefore that this is true, the marked presence of the two side columns also in this painting is a clue that suggests that the mutilation of the Louvre panel's edges really took place, even in relatively recent times, although the scholars still quarrel such assumption.

Among the several replicas of the original *Gioconda*, the so-called *Mona Lisa Reynold* (**FIG. 6**) is particularly interesting, because it shows, more or less like that of the Prado, an excellent definition of the colours that are presumed to be the like original ones,

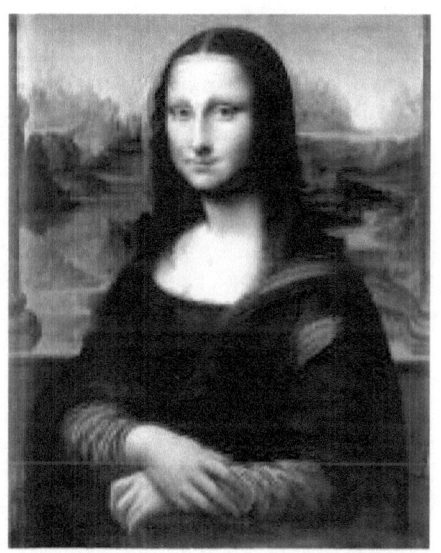

FIG. 6

namely the same that can be imagined once the recalled repaintings were removed from the Louvre panel. This reproduction takes its name from one of its owners, the famous painter Sir Joshua Reynolds, who in 1790 received it as a gift from Francis Osborne, Duke of Leeds, who in turn acquired it from the portraitist and art theorist Jonathan Richardson (1665-1775). The painting then got the gallery of Sir Abraham Hume in 1795 by the liquidation of the Joshua Reynolds' collection of ancient paintings, with the reputation of being an original by Leonardo,

given the extreme accuracy of his pictorial *ductus*. Today the analytical and diagnostic investigations have shown that, being it perfectly overlapping to the outlines, proportions and details of the Leonardesque model, it would be a copy obtained by mechanical transposition carried out directly over the original, likely by an expert Nordic painter. This is shown even by the dendrochronological examination of the three oak planks whose the support is made up, belonging to a timber variety spread in the eastern Baltic area, which were instrumentally dated between 1602 and 1634, a chronology that is consistent with that of the materials and of pictorial technique, which refer to the North-European tradition between the end of the 16th and the first half of the 17th century[82]. It would be, therefore, a copy painted at Fontainebleau, presumably around the early seventeenth century, which would show the original appearance of the colors arranged by Leonardo even before the patinations altered them: as the Prado copy and digital restoration, even the *Mona Lisa Reynolds* is a particularly precious document, as we shall see, to deal with an allegorical reading of colours.

So, the 'mystery' of *Mona Lisa* extends in various ways to all her 'twins'. Despite the questions raised in each copy, all replicas of the *Gioconda* and the performed studies using the most sophisticated techniques, both on them and on the original, allow, almost reassembling the tiles of a mosaic, to perfectly restore nowadays the ideal appearance of the portrait painted by Leonardo, making unadvisable any proposal of cleaning and removing the non-original paints over the Paris panel, though it is also a never-ending argument. After all, only the Louvre *Mona Lisa* has become the *pop*-icon of painting, a *Mona Lisa* showing proudly the signs of time and an unseemly make-up, but whom we still love as it is.

A NOT-PORTRAIT

From reality to allegory. A conceptual portrait

What was been explained up to here allows to state some early conclusions and to clarify why was made the opinion, widespread among scholars and the most attentive devotees, that Leonardo did not want just to create a true portrait, but an idealized figure. About this latest point, according to current knowledge, one may only agree. How this idealization course of his alleged model has taken place, and if it had been conceived formerly in the initial intentions by Leonardo or arose during the restless execution, is a subject that can stimulate the palates of academics and scholars, but appears lesser than the ultimate meaning of the matter, which we must be dealt with. That is the image of the so-called *Gioconda* the way we received.

To my mind, I feel that is very close to the truth whoever believes, such as, for example, Martin Kemp and Carlo Vecce, albeit with different motivations, that Leonardo actually begun the painting as a simple portrait in 1503 in Florence and then interrupted it several times during the years later, also due to his trips outside Florence, up to leave the painting in 1508 unfinished, unless the «head», given the same reasons he did not fulfill the *Battle of Anghiari*. The reports collected by Vasari and the drawing of Raphael, which are restricted only to the sitter and the setting, should refer just to these years. Being a transportable portrait, it would believable that Leonardo, having perhaps friendly agreed the renouncing to the commission with Francesco del Giocondo, liked to bring it with him in his new Milanese stay, then slowly transforming the face with continuous tweaks. And only after his transfer to Rome in 1513 he would have completed the landscape at the upper side and the other details, according to the behest («*instantia*») of Giuliano de' Medici, as

the same painter admitted at the presence of Cardinal d'Aragona, probably eager to encourage his *protégé*, during his troubled Roman stay. So, as suggest the most aware scholars, only at that time the «unfinished» portrait has got to the painter a chance to progressively transform it into a personal iconographic meditation on the deepest truths concerning Nature and Mankind, following his most mature considerations reflected in the *Codex Leicester* and in the notes he wrote down during the French stay.

My thought partially agrees to these hypotheses, but is more articulated. The starting point is that, given the lot of oddities that have been remarked into the composition of the picture, regarding the conventions of current portraiture, the iconographic model adopted by Leonardo himself, even the drafting of the landscape, it is clear that the *Gioconda* is not a portrait like any else. Its eccentricities support that Leonardo fancied focusing in it a completely different subject than the mere portrayal of a woman's face within a panoramic view, transcending from the simply representative degree to reach consciously the allegorical, or, for better to say, the *conceptual* one. Just the existence of a conceptual content that eludes the rules of portraiture is, in my opinion, the solution to the 'mystery' that is perceived at a glance into the painting. But what would be, at this point, the subject of the Leonardo's meditation?

We already noticed that Leonardo has evolved the portraiture, purposing to depict not only the physiognomy, but also the inner world of his characters, the so-called «motions of the soul», and, as a follower of the experience and son of Humanism, has concerned to give a shape to the thought, namely to paint the «man and intention of his soul» («*l'uomo e 'l concetto della mente sua*»)[83]:

176. A good painter has two chief objects to paint, man and the intention of his soul.

The good painter has two chief objects to paint, man and the intention of his soul. The former is easy the latter hard; because he has to represent it by the attitudes and movements of the limbs; and the knowledge of these should be acquired by observing the dumbs, because their movements are more natural than those of any other class of persons.

Then, when *Mona Lisa* gave up being the portrait of Lisa Gherardini and began to depict an idea, this concept could only reflect the mind of Leonardo himself. He gets us on this path when, several times in his writings, and mainly in his *Treatise on painting*, he comments on the widespread conviction that «every painter paints himself», that is to say that a painter basically does nothing but reproduce himself [84]:

487. How the painted figures often resemble their masters.

It happens that our mind is what moves the hand to create the features and different appearances of the figures until they satisfy us; and because this judgement is one of the faculties of our soul, which is composed into the body form, where is living, according to its will, so that, having with our hands to redo a human body, we willingly reproduce that body, whom it [the soul, nT] *created first. And it explains why who falls in love, willingly falls in love with someone that is similar to himself.*

But in what sense can such a statement be taken in account? Certainly not as a desire by an artist to project himself empathetically into his pictures: it seems that, when Leonardo invokes a «judgment» that proclaims as «ours», he means a non-subjective but objective principle that appeals not so much to an alleged innate, hence unique, faculty of human reason, but to an external, impersonal, i.e., universal rather than particular, criterion.

Rejecting the neoplatonic aesthetic idealism by Ficino and,

to some degree, also by Alberti, and, in particular, discarding the existence of a universal connatural faculty concerning the aesthetic judgment, Leonardo involves the Aristotelian and scholastic theories about the correspondence between soul and body to declare that the plurality of judgment comes from the variety of the individual souls, being them a particular form of the variance of the bodies, proving to follow more a physiological, materialistic, hippodamian, than metaphysical or philosophical suggestions. Therefore, being for the Vincian the judgment an expression of the soul, to avoid the particular relativism in judgment and creation, he relies to the cornerstones of the great classical Pythagorean-Platonic tradition, which relates the Nature and the abstract *lògos*, to recover the primary principles about the universal Beauty and Truth. This is the case, for example, of the human proportional harmony: since every artist might subjectively rely on imperfect proportions, figuring his own appearance or a particular thought by his own mind, it is necessary to resort directly to Nature to deduct the *episteme*, the universal norm, through the empirics. Otherwise we should rely on a judgment that has to be «ours», that is to say dialectic, shared by a great amount of human beings that leads, almost socratically, to determine the objective truth about beauty and perfection of proportions[85]:

> *Be on the watch to take the best parts of many beautiful faces of which the beauty is established rather by general repute than by your judgment [...]*

All that brings Leonardo closer, as Kemp rightly points out[86], to the great classical tradition of idealized naturalism and to the selection principle meant by Zeusi's legend[87], but also to contemporary humanistic thoughts, mostly to what theorized by

Alberti (*De Pictura*).

Therefore, one shall not accept the desire by Leonardo to self-portrait himself in the *Gioconda*: he, indeed, blamed his colleagues who fell into the vice of the self-mimesis – «every painter depicts himself» was a saying at his time –, i.e., reproducing themselves in their paintings, both physically, by depicting their own appearance, and morally, projecting their own inner world, judging this act to be the most serious fault in which could fell an artist[88]:

105. Of the greatest fault of the painters.

The extreme fault of the painters is to replicate the same expressions, faces and drapery in the same picture, and to figure the most faces look like their master, which has often given me admiration because I know some of them in all their figures seem to portrayed themselves from life; thus, in those we see the attitudes and the manners of their creators, and if they are lively in speaking and in moving, their figures look like them; and if the artist is devout, the figures appear with their bowing necks; and if the master is worth little, his figures seem the lazyness taken from life ; and if the master is disproportionate, his figures are similar; and if he is mad, in his compositions he shows himself clearly, and his characters are inconclusive, and not attentive to their acts, indeed, some of them look in here, others in there as if they dreamed: so everyone follows messy in painting just the painter's own mess. And having repeatedly pondered the cause of this fault, it seems to me that it should to be considered that the soul that rules and manages each body is what creates our judgment. So it manages the whole depiction of the character, until it judges it to be well done, even with a pug nose, or short, or long , and this way he sets the height and physique. And such a ruling is so powerful, that it directs the painter's arms and gets him to portrait himself, seeming to his soul that this is the right way to picturing someone, and whoever does not do like him is mistaken. And if the soul finds someone who resembles his body, which it has created often falls in love with it. And this is why many people fall in love and marry

who resembles them, and often the children born by such people resemble their parents.

In this conceptual *milieu*, the Leonardo's refusal toward the self-portrait, to «paint himself», his purpose to catch an impersonal reality, unrelated to any individual «judgment», may have led the artist to depict in his masterpieces the objective truth about the Nature, drawn from the experience and rigorous study of its laws and causes, the so-called «*ragioni*». This truth, if anything, settles into the mind of the painter-scientist, forming it, in such a way that he would be able to translate within his 'invention' not a subjective, but an objective and universal content. Leonardo himself warns that the universalist feature should be the ground of the painting[89]:

The mind of the painter should be like a mirror which always takes the colour of the thing that it reflects and which is filled by as many images as there are things placed before it. Knowing therefore that you cannot be a good master unless you have a universal power of representing by your art all the variety of the form which nature produces – which indeed you will not know how to do unless you see them and retain them in your mind [...]

In other words, I suggest to glimpse the same habit that Leonardo used to have in his graphic reproductions of natural phenomena, or machines, scattered in his codes, in the Lisa Gherardini's portrait managing. Which, at this point, should be actually believed as a non-portrait and, instead, as a *conceptual* representation of Nature by its constitutive and universal grounds. Thus, what are these grounds?

CHAPTER TWO

LEONARDO AND THE FOUR ELEMENTS

There is none 'woman of mystery' to be found in the *Mona Lisa*; instead of the portrait of the wife of Francesco del Giocondo, we discover an allegorical picture that associates a female sitter and a landscape with a universal concept that Leonardo fancied to depict as a *summa* of his knowledge and his own empirical researches about the foundations of Nature. And as a point of arrival of his extraordinary scientific painting.

I believe that Leonardo, as shows his wholly independence with respect to preconceived conceptual models and his refusal to rely on both conventional metaphorical structures and current symbolic codes, even if drawn from the classicist iconographic heritage in vogue, he would have been rather willing to elaborate in the *Gioconda* a sort of 'automatic' translation of the subject in an allegorical *formula*, without relying on pre-established iconographic models, but arranging the composition following the indications given by the content itself.

That is why the Louvre wooden panel appears at a glance

not as a common portrait of a woman, it doesn't matter if Lisa Gherardini or another person, but as a picture that, transcending the limit of time and contingency, rises to the ground of timeless and metahistorical Absolute, so that infers those doubts and questions that justify the perception about the existence of a 'mystery'. Then, if the *Gioconda* were actually an allegory and not a true portrait, what subject would it be depicted?

Earth, Water, Air, Fire

To answer this question we ought to bring virtually back the time till the moment when Leonardo left the portrait and then to recover the original appearance of the painting, unfortunately today altered by overlaid dyes; to this purpose we should take into account the best older copies (*Prado Mona Lisa, Isleworth Mona Lisa, Oslo Mona Lisa, Mona Lisa Reynolds, Vernon Mona Lisa*) and the virtual restitution by Pascal Cotte, that appear, at the current knowledge, the images at our own disposal that more than any other else would probably approach the authentic *Mona Lisa*. I suggest observing carefully in the Prado replica, which perhaps has retained the original colors more than any other, the lower left part (with respect to the observer) of the landscape, just above the balustrade, which shows a ridge of mountains where opens a narrow gorge from which came down a sort of 'pathway' with two narrow hairpin bends shaping a serpentine. The features of this glimpse show a bright red-orange tone colour, also noticeable into the restitution by Cotte, which clearly stands out from the close cold tones of the lake and the mountains in the distance that overrule the upper part of the table. This peculiarity seems to me to have completely escaped

the eyes of the many scholars who examined the *Gioconda* and simply recognized in that tortuous shape a sort of path, or road, which climbs sinuously through the mountain gorge, or the riverbed of a dry torrent, neglecting to analyze the evident singularity about the colour, comparing to the other parts that set the landscape.

This neglect by the criticism seems the more singular the more it is noticed that all copies and versions of the *Gioconda* repeat identically both the same landscape details (in fact, they are the ones that are replicated exactly), and the same bright red-orange (*Mona Lisa Isleworth*, Oslo *Mona Lisa*, *Gioconda Reynolds*, *Mona Lisa* Vernon) or red-brown colour (*Saint Petersburg's Mona Lisa*), of the Prado copy. Even in the Louvre original this part of the painting, although misted and obscured by the protective varnishes, differs from the rest of the scenery by a reddish-brown tone that odds sharply with the cold colors of the upper landscape. It is, therefore, not the red colour of the preparatory primer, made up by copper carbonate, that Leonardo used to spread in the lower part of his paintings (blue in the upper part, instead) to enhance the surface colors[1] and that might emerge by the cleaning of the Louvre painting, or as the result of the alleged incompleteness of the painting[2]: the comparison with all the copies, and mainly with that of the Prado, allows stating that Leonardo consciously wanted to lend this part of the landscape a reddish colour.

I propose to recognize in this section of the scenary, instead of the riverbed or the course of a river, an ideal reproduction of some volcanic formations in activity which are effusing a lava flow that runs sinuously among the rocks. The typical light that spreads around because of eruptive events is the one that Leonardo impressed in this corner of the landscape that shines for this reason for a bright red colour.

Since there are many points in his writings in which he dealt with the volcanic events and effusive phenomena[3], I believe that his informations may have been taken from literary sources or from third-party descriptions, rather than from direct experience, since his biography lets exclude that he had gone personally to the active volcanic sites and witnessed an eruption. The Vinci genius had, on the other hand, a great expertise about the civil and military metallurgy, which he had personally practiced during the years of his apprenticeship within the workshop of Andrea del Verrocchio, an excellent bronzesist as well, and had further improved along his first stay in Milan, thank to the enterprise, unfortunately failed, of the equestrian statue for Francesco Sforza, for whose realization he submitted himself in his famous cover letter to the Duke of Milan. For just this purpose from 1491 to 1493 he attended the military foundries, the arsenals, and carefully studied the metallurgical techniques by extraction, refining and melting; he spent a long time amidst the gleam of the ovens and observed the molten metal castings among the refractory material, noticed the glare of the aflame material, and probably would conceived likewise the scenario of a volcanic eruption. We can therefore forgive Leonardo, due to his lack of direct experience on eruptive phenomena, for some slight inconsistencies within the pictorial rendering about a volcanic landscape and the lava stream that flows between the rocky inlets behind the *Mona Lisa*.

Yet he was well aware, as already seen, that a volcano is connected at once to the idea of fire and believed that, in its analogical vision between the 'body of the earth' and the human one, this natural element is connected to the energetic *pneuma* (spirit, soul) that animates the life («and the dwelling-place of the creative spirit is the fires»)[4]. Besides, he related the fire to the typical red color that is given by the lighting enlivened by

this element and that is precisely what one notices in the details of the landscape depicted to the left (with respect to the observer) behind *Mona Lisa*'s shoulders[5]:

> *[...]arrange that there shall be a great fire, then the objects which are nearest to this fire will be most tinged with its colour; for those objects which are nearest to a coloured light participate most in its nature; as therefore you give the fire a red colour, you must make all the objects illuminated by it ruddy; while those which are farther from the fire are more tinted by the black hue of night. The figures which are seen against the fire look dark in the glare of the firelight because that side of the objects which you see is tinged by the darkness of the night and not by the fire; and those who stand at the side are half dark and half red; while those who are visible beyond the edges of the flame will be fully lighted by the ruddy glow against a black background.*

These clues lead me to believe that Leonardo wished to depict in this part of the landscape an allegory of elementary Fire. Such hypothesis allows to extend similar analogies to the whole *Gioconda* landscape. If we take into account the two distinct parts that compose the scenery, to the left and right of the sitter, the notable odd between the warm colours of the lower areas (the eruptive form on our left and the panorama with the bridge on the right) and the cold ones of the upper parts, and even the divisions set up by the mountain ridges in the middle of the view, then we are able to regard the whole field of the landscape divided into four quadrants. Once this space division has been assumed, the idea that one of these quarters would be occupied by an allegorical representation of the elementary Fire allows to extend the same symbolism to the remaining quadrants, in which would be placed the other three components of the so-called *theory of four Elements*: Air, Water, Earth.

Contrary to the easy chance to detect in the quarter above

the field of Fire, namely, in the upper left part (with respect to the observer) of the landscape, an allegory of Water due to two lakes within this quarter – one above smaller of high mountain (barely perceivable also in the original of Paris as well) and other below greater as a piedmont lake –, I propose to attribute to this side a representation of the Air element. This is for two reasons. First of all, I suggest to bear in mind what Leonardo stated about the causes of high altitude springs. In the last decade of his life he spent a lot of energies to provide a solution to this matter, whose investigation occupies a considerable part of his meditations saved in the *Codex Leicester*. Contrary to his early convictions, according to which underground water veins reach the mountains and emerge from soil cracks, like the blood internally wets the man's brains and drips from a wound, he agreed, after careful investigations, that the generation of wellsprings and lakes at altitude would rely by vaporized water masses suspended amongst the air, due to the effect of solar heat, and by their subsequent descending as rain or snow, alike to what happens during the distillation.

The great function that Leonardo grants to the air about the water cycle, which has direct consequences, as we will see, to the develop of his theory about the perspective, better known as 'aerial perspective', is the second reason that leads me to believe that this quarter of landscape holds an allegory of the aerial Element. Taking into account the best color rendering of the copies, such as that of the Prado and the *Mona Lisa Reynolds*, one can easily deduces a clear example of Leonardesque 'aerial perspective' in this landscape's quarter, where the darker colours of the mountains get gradually azure by the density of the atmospheric vapores, up to merge themselves into the bright blue sky.

It is not really difficult to recognize in the quarter near to the

field of the Air, namely in the upper right part (with respect to the observer) of the landscape, a depiction of the Water element. It is denoted by the large alpine lake placed in a wide valley among high peaks that amounts to three the number of alleged lochs within the *Mona Lisa* landscape – the point should not be meaningless to those who wrongly relate the *Gioconda*'s scenario with the aforementioned Leonardesque description about the Golfolina two lakes –; from this latter, jumping a rocky height gap, a river seems to come and flow down along the valleys in a sinuous course.

Leonardo was addicted to the water. As a hydraulic engineer he spent most of his experiences and studies about the applicative and theoretical hydrodynamics issues, stating some extraordinary suggestions on the great power of water to modify and 'draw' the morphology of the earth.

In the Louvre painting and in its similar copies, the mountain ranges, which in this part of the landscape appear to be unfolded by the waters of the underlying lake as if this element were have transformed them, and the shape of the piedmont landscape modified by the strength of the river seem very close to the spirit of the meditations about the water phenomena that Leonardo described within his *Codex Leicester* and the apocalyptic drawings of the Windsor Castle *Diluges*. The azure color that rules in this quarter of the landscape is a further evident reference to the features of the Water, but also a remarkable application of the criteria of the aerial perspective in continuity with the close field of the Air.

Obviously, the last quarter in the lower right corner would be occupied by an allegory of the Earth element. In this case it needs necessary to refer to all the *Mona Lisa* copies, as well as to the Louvre original, because they do not display in this part a same scene. In fact, the *Isleworth* (or *Early Gioconda*) variant and

its similar one from Oslo do not show the controversial bridge, neither the river below, which, however, appear very clearly in the other copies, but only a valley among ordinary hills. Taking into account just these differences, we realize that Leonardo longed to depict in this quarter a generic, almost 'picturesque', territorial view, with all the items that recur more commonly within the Earth sphere inhabited by man: hills, meadows, rivers, rocks, and the inevitable man-made artifacts, as part of a whole *kulturlanschaft*. And its corresponding colors: the greens, the browns, the ochers, masterfully merged into the moist atmosphere that progressively 'azures' them – a detail that all copies and versions of the *Mona Lisa* hold despite some different features –, which are typical of Apennine Tuscan landscape. However, Leonardo's choice to deprive it of any sign of vegetation and life turns it into a primordial, abstract, almost apocalyptic scenery, which makes its identification with a exact place unlikely. Any idea or purpose of a realistic reproduction has to be left out. All that remains is to attribute to this glimpse an allegorical depiction related to the Earth element.

However, before deeping further the relationship between the four Elements and the *Gioconda*, we need to sum up the Leonardo's belief about the quaternary composition of matter. This task is rather hard to deal with, because the Leonardo's asitematic treatment does not allow a clear deduction of his thought, so we must rely on some passages spread throughout his codes to gain deductively a conceptual framework that, in this case, agrees to the most classical Empedoclean-Aristotelian theory on the four Elements, which believed them as the primary substances whose all beings within the sublunar world were made.

It might seem queer that Leonardo shared with his whole generation a still faith on such a belief, but it must be taken into

acount that his knowledge did not based on *a priori* acceptance of notions coming from the *auctoritas* of ancient texts, but rather on an empirical, open-minded, investigation that, if anything, supported, completed, specified *a posteriori* the beginning data drawn from the contemporary science of Nature. In spite of its autonomy of mind, despite proclaiming himself «a disciple of experience»[6] and of Nature, which is «mistress of masters»[7], Leonardo shows to gain most of his knowledge from the assumptions of the current scholastic Aristotelianism that not necessarily his searches might contradict. Thus, for instance, it is not surprising that he did not question the geocentric theory and the Aristotelian cosmological model, although he had investigated not a little about the celestial bodies and had also gained the early correct deductions about the moon surface. After all, he was a son of his time.

In order to understand his position regarding the theory of the four Elements it is necessary to concern all the assumptions, still strongly conditioned by the medieval Aristotelian speculation, focused on the commentary and the integration of the Stagirite writings (above all, the *Meteorologica*, the *Generatione et corruptione*, and the Φυσικῆς Ακροάσεως) – in which many elements of the pre-Socratic speculation are merged, especially by Empedocles, Pythagoras, and also Plato (*Timeaus*) –, that still at the time of Leonardo explained the composition of the matter and the physics of bodies. According to this mindset, all the beings into the sublunar world would be made up ontologically by a free aggregation of the so-called four Elements (*rizomata* by Empedocles[8]), usually called Earth, Water, Air, Fire, believed as declensions of the unique universal substance, and also corresponding to the four physical states of matter: to the Earth the solid, to the Water the liquid, to the Air the gaseous, to the Fire the pneumatic-energetic one. The Elements would be arranged

according to their own density and weight in a concentric order with respect to the earth's core, forming spheres, going from the heavier Earth element, to gradually getting, through the spheres of Water and Air, to the thinner element, the Fire. The upper-moon world, on the other hand, would be composed by the ether or quintessence, called also by the medieval philosophers of Nature and the alchemists as the first matter (*prima materia*): it would be the synthesis of the four Elements, the universal substance of the Cosmos, a pure and diaphanous substance whose the moving stars and their relative spheres, as even the fixed stars would be made.

The free and never-ending aggregation of the four Elements, the reason for which every single 'mixed' body within the sublunar world is made up, would be due to the action of solar radiation and the planet influences, which even would not allow the separate arrangement of the Elements above earth surface, according to one's own state. The unlike combination and density of the Elements would also cause the gravitational motion of every beings: in fact, since each of the four material root would tend to reach spontaneously its own sphere, its percentage amount regarding the composition of every being would determine the dynamism and the particular gravity of any 'mixed' body.

According to the Aristotelian tradition, the four elements would also feature by some prevailing qualities: the Air is connected to the wet, the Water to the cold, the Earth to the dry, the Fire to the heat. By the rule of attraction, or *philia* (love), and repulsion, or *neikos* (hate), couples of mutual sympathies (*combinationes*) between the Elements and their prevailing qualities are established: Water is suitable for the Earth, the Air to the Fire, the cold to the dry, the heat to the wet. In the same way, there are as many oppositions (*contraria*): the Air is improper to the

Earth, the Fire to the Water, the wet to the dry, the heat to the cold. Following an ancient tradition, dating back to Philistion of Locri (4th century BC) and yet to Aristotle, each Element would include, besides its own prevailing quality, also a combination of a couple of other similar ones: thus, the Air would contain the heat and the wet, the Water the cold and the wet, the Earth the cold and the dry, the Fire the heat and the dry. Aristotle attributed to the double qualities of each Element the accidental features, resulting from their own material structure, held responsible for their physical habits and exterior properties. This belief would have allowed the transformation from one Element to another, by subtraction and substitution of one of its accidental quality by another. On this basis we would explain the generation and corruption (*mutationes*) process of whatever being, which would be caused by the transformations of the Elements and the accidental qualities that would compose them. Such courses could be artificially induced by working instrumentally on accidental features, for example, thanks to the action of an external heat source that would subrogate the combination processes and the state change caused by solar radiation.

The assumptions by ancient physics were the subject of many integrations and developments over time, especially thanks to the Arab commentators of Aristotle, such as Avicenna and Averroes, that brought great results into the speculation of medieval school theologians – among them we remember mainly Roger Bacon, St. Albertus Magnus, St. Thomas Aquinas, William of Ockham and John Duns Scotus – above all about the question of 'mixed beings', up to be established in 16th century as a fundamental system of notions about Nature, recognized also by Leonardo.

The consequences of the theorization and the diffusion of these conceptions on the composition of the bodies, being

practically shared in every degree, were remarkable into the knowledge and practical applications; they set until the late Renaissance a weld among the several disciplines that were based on the alleged quaternary structure of matter and had to do with the manipulation of natural substances, as in the case of medicine and alchemy. Just to stay within the interests of Leonardo, it is useful to remember the outcomes in the clinical scope and, in particular, the theory of the four humors attributed to Hippocrates and afterwards improved by Galen of Pergamon (*Claudius Galenus*). It was based on the recognition that every human being was made up also by the same four Elements and their respective qualities that would compose any sublunar entities, such that each of them would be associated with a physiological-behavioral property (temperament) and a specific organ: to the Water (cold) the phlegm or sap, phlegmatic humor and head; to the Earth (dry) the black bile, the melancholic humor and the spleen; to the Fire (warm) the yellow bile, the choleric humor and the liver; to the Air (wet) the blood, the burning humor and the heart. Everybody would have been internally featured by the preponderance of his own humor, which in the health was supposed to be balanced with the other humors and Elements, so that it would cause some typological behavioral properties (temperaments). Therefore, the general therapeutic procedure tended to restore the original balance among the humors, or to hinder the typical humor by an onset disease with the its opposite one, according to the principle «*contrariis contraria curantr*»[9]: for instance, people who would show an alteration with the Earth features, partaking the dry and melancholic humors, should be treated with moist and cold medicines. This approach, which still has a popular credence even today, set the orientation of the theory and therapeutic practice throughout the Middle Ages and the early Renaissance, well beyond the

time of Leonardo, until the establishment of iatrochemistry occurred around the middle of the XVI century.

What does all this have to do with *Gioconda*? Let's go back to the starting point: not unlike his contemporaries, Leonardo trusted the Aristotelian physics and the theory of the four Elements, especially regarding the speculative and practical aspects involving cosmology, mechanics, human physiology, medicine and, as we will see, painting. Also in this case it is possible to deduce these statements only by the analysis of his thoughts scattered in the labyrinthine *corpus* of the Vincian codes, due to the lacking of a real systematic exposition on this subject.

For example, in a synthetic passage expressed in the *Codex Atlanticus* Leonardo proves to rely the speculation of the ancient Greek naturalist philosophers about the unitary and conservative structure of cosmic matter, from which the four Elements would came from, which would explain the consequent metamorphism of every particular being[10]:

> *Anaxagoras.*
> *Every thing proceeds from every thing, and every thing becomes every thing, and every thing can be turned into every thing else, because that which exists in the elements is composed of those elements.*

Already at the time of writing the *Codex Forster III* (1495-97) and the *Codex Atlanticus* (1503-5), Leonardo, investigating the gravity and the dynamic of bodies, referred to Aristotelian physics in his statements about the concentric arrangement in the quiet of the four Elements' spheres below the moon, and about the motion induced into the 'mixed bodies' by their internal composition, because of the 'desire' of each Element to go back to its own original place[11]:

As the fire is the lightest element, so does not even have resistance; and if it were possible to bring some quantity of air to its full height, this air would hole everything, without ever giving rest to its ascent, until it reaches its sphere. Likewise, being the air more light than water, having the air little resistance; whence, when the water evaporates to high, it is reduced to its elementary structure, and from there it falls, piercing the air which it can not resist, and to its element for the shortest path to the bottom of the water it leads itself [...]. Aristotile says that everything wants to keep its nature. Gravity, being lacking into the thin things, desires that site, in which it no longer weighs, and that its density be weightless.

This ancient belief in the Empedoclean-Aristotelian 'grammar' of the four Elements was so steady in Leonardo that it became a subject for some brilliant and original narrative elaborations, as his usual given to his habit as a witty teller, whose the following delightful tale could be held as example[12]:

The water on finding itself in the proud sea, its element, was seized with a desire to rise above the air; and aided by the element of fire, having mounted up in thin vapour, it seemed almost as thin as the air itself; and after it had risen to a great height it came to where the air was more rarefied and colder, and there is was abandoned by fire; and the small particles being pressed together were united and became heavy; and dropping from thence its pride was put to rout, and it fell from the sky and was then drunk up by the parched earth, where for a long time it lay imprisoned and did penance for its sin.

Even Leonardo assumes that every being would display, as has been observed, its features by its own weighted or proportional internal combination of the four Elements, so that namely to explain the mechanic and physical phenomena, Leonardo focused his attention on the properties of these basic structures of matter, demonstrating his clear epistemological inde-

pendence from the metaphysical or theological speculation developed on this subject by medievals[13], but rather relying on his own personal deductions and experiences. Just during his second stay in Florence, at the time of the likely commission of the *Gioconda*, coinciding with the apex of his studies on the nature of the Elements, Leonardo shows skepticism about the possibility of grasping the essence («*quiddità*») of each Element, but not so for the experimental acquaintance of their phenomenal and sensitive data, i.e., relating to physics and dynamics[14]:

> *[...] the definition of the essence of no element is in the power of man, but most of their effects are known. And we take to our advantage the properties of their gravity and lightness, although we can not say the truth about the simple elements, because among us they are not found.*

We belive why Leonardo in the *Codex Arundel* states a sort of abstract definition of Element, as Andrea Bernardoni rightly observes, coming from the mere physical (mass, volume) and mechanical (gravity, motion) properties that would be remarked empirically[15]:

> *2 are the qualities of the elements, that is, thinness and density; thin is said to fire, air and water; dense one can tell only to the earth.*
> *2 are the quantities of each element, that is continuous and discrete.*
> *2 are the natural motions of the continuous elements and discrete elements, that is, motion of elevation and motion of descent.*
> *2 are the figures that the elements perform running away discontinuously from each other.*
> *2 are the causes because one element flees from the other.*

Elsewhere, however, Leonardo appeals to the ancient Aristotelian-scholastic conception about the *oppositiones* (*contraria*) and the affinities between couples of Elements to explain the

natural dynamism of bodies[16]:

> *The elements drive away or attract each other, as can be seen when the fire, entered as heat at the bottom of the boilers, drives away the air and the air escapes through the boiling surface of the boiling water. And yet the flame attracts the air to itself, and the heat of the sun draws up the water in the form of wet steam, which then falls as dense and heavy rain.*

Leonardo had also studied the physics of each Elements for a long time. I like to think that the first which attracted his attention was the Fire, perhaps thanks to the chances he has got to do with the forges that his master, Andrea del Verrocchio, an expert bronzist himself, gave him during his apprenticeship. This attendance never ceased by necessity, as already said, to provide for the requests of Ludovico Sforza as his military engineer and, above all, by the chance of the unfortunate enterprise for the equestrian monument to the duke Francesco. Perhaps some of the most original assumptions concerning this Element are deduced by his studies on the gunpowder explosions, for which, due to the presumed metamorphic actions triggered by heating sources into the Elements, the Vinci genius hypothesized that the compact and solid mixed mass, whose nature should be predominantly Earth, would get on the energetic form of Fire, visible through the 'vapors' of the explosion: it would result a volumetric expansion, typical of this Element, such as to pull its force of pressure to the bullet[17]. Despite, therefore, the traditional belief in the great levity of Fire and Air, to explain the phenomenon of the explosion of gunpowder, Leonardo states that all the Elements would be able to acquire material mass and weight thank to a condensation process[18] – this deed demonstrates again his mind autonomy with respect to the

current assumptions and the principle of ancient texts' *auctoritas*, if were contradicted by experiments. He admits that, once again from an independent position from the ancient authors («*altorì*»), the physical properties and gravitational conduct of each Element would not be subjected only to the simple attraction toward its own sphere, but would also related to the mass, the density and physical state, as well as to the type of aggregation in the 'mixed' bodies[19]. This implies that, in theory, even large amounts of elementary Air or Fire could acquire notable density and weight if they are strongly concentrated or they prevail in the composition of 'mixed bodies', as could also happen into the metals[20]:

> *The fire is light in its sphere, and it will be as much as in a heavier element.*
> *No one prime Element has gravity or levity in its sphere, and if a bladder filled by air weighs more than empty, this is because the air is condensed. And condensed could be even the Fire, which would be more heavy than Air or like Air, and perhaps more heavy than Water, and get itself like the Earth.*

It seems, therefore, that Leonardo conceives the Fire as an element that has got properties of mass, volume and structure comparable to those of any other Element. It should not differ from the others either because of its corpuscular shape. Actually, moving from the medieval theory of *minima naturalia*, namely the minimal physical limit for each Element as a compromise between the discrete structure and the substantial unity of matter, he attributes to each Element a geometric dimension based on its physical and mechanical features, neglecting, as he used, to deal the question by ideal and metaphysical terms[21]. Fascinated by geometry and willing to mind the shape of every being as required by nature due to its own function, in the *Manuscript F*

Leonardo deals with the identification of the Elements with the geometric solids according to the Platonic tradition and states that, due to their properties of expansion, compression and movement, the minimum particles of Water, Air, Earth and Fire would have a spherical shape[22]. In the case of the Fire element he clearly refers to real spherical «drops of flame», describing them as elementary corpuscles that would cling together to perform an elongated shape[23].

Among the greatest merits that have to be granted to Leonardo should be also included his studies as promoter of modern aerodynamics. His interest toward the Air element is already well documented from the beginning of his first stay in Milan and has been actualized into his pioneering experiments for human flight, taken from his searches about the bird structure that had given life to his *Treatise upon flight of birds*, dated 1505, now hold in Turin. The consequences of these researches in the pictorial scope were previously glimpsed, especially with reference to the so-called 'aerial perspective', in which the density of the interposed air masses plays a fundamental role in the reproduction of the optical depth, influencing the eyesight of everythings at the distance more and more evanescent, and even of their colour, due to their gradual 'blueing'. This phenomenon was correctly attributed by Leonardo (*Codex Leicester, Treatise on painting*) by the suspension into the atmosphere of corpuscular forms of Water, excited by the solar heat action[24]: the supposition, however, substantially confirmed the assumptions by Aristotelian physics that assigned to the Air element the humid-heat quality, placing its sphere above the contiguous one of the Water.

The great theme of Water was developed by Leonardo almost along his whole life, both from a professional and a theoretical point of view. All his patrons did entrust him as a

hydraulic engineer: so Ludovico Sforza for reclamation of the Pavese land, the city of Venice for the defense against the danger by the Turks, the Florentine republic for its plan to deviate the Arno river to harm its enemy town Pisa, the pontifical government for the drying up the Pontine lowlands. The designs for sluices, drains, channels and hydraulic lifting devices that constellate his codes show a great acquaintance with fluid dynamics; vortices, turbulences, state changes, occupy most of the Leonardesque pages and notably those of the *Codex Leicester* and of the *Deluge*'s drawings, where his meditations about the destructive and modifying force of the waters get to a dramatic intensity.

Finally, the Earth. This element had been studied by Leonardo at the same time as his observations on the geological stratifications and the metamorphism of the earth related to the water cycle, from which he deduced his suggestions about the origin of rocks and mountains as results of awesome cataclysms. The earth's crust would be subject to continuous mutations and transformations due to the presence of huge underground cavities, whose collapse would produce earthquakes and mass shifts, whereas the action of the «water veins», both in depth and in surface, would outline its profile and would cause continuous metamorphoses. Since for Leonardo the «pure elements are not given in nature»[25], but only as 'mixed', namely as compounds, every kind of sediments and rocks would be the result of various combination of Earth with parts of Water and of the other Elements which they would determine physical (mass, density, weight) and functional (compactness, resistance, etc.) features. Even the Earth element would be exposed to the action of the «vegetative soul» that would display itself in natural phenomena, as part of a living Universe subjected to the corruption and generation cycle, in an absolutely similar manner, states Leonardo,

to the flesh, the cartilages and the bones of the human body, coherently with the analogical belief that related the 'major world' with the 'minor world'.

The supreme landscape scenery of the *Virgin of the Rocks* is perhaps the most exemplary manifestation of Leonardesque metamorphic conception on the Earth as a living 'body', in whose internal cavities grow rocky formations, such as stalactites and stalagmites, fed by the action of the waters, similarly to what it would be recognized to the plant species depicted nearby them: according to the *weltanschauung* of the Ancients, in which there was no distinction between the inorganic and the organic world, it was absolutely legitimate, and this also for Leonardo, to imagine only a Cosmos alive in its entirety, including rocks, minerals, vegetals, animal and human beings.

Even the metals were accounted as living entities, subjected to the same process of continuous generation, transformation and decay, as typical of any other species in nature. This awareness, coming from the Aristotelian speculation and in particular from the *Meteorologica* books, which surely were much studied by Leonardo during the latest part of his life[26], had been strengthened and spread thank to the theoretical assumptions related to Hermes Trismegistus and his *Corpus Hermeticum* which, from the time of its translation into Latin and the publication of his *editio princeps* in 1471, both edited by Marsilio Ficino, greatly influenced the naturalistic and humanistic Renaissance studies[27]. It is not meaniningless to note that a copy of the book of «Ermete filosafo» – as it is recalled in the inner cover of the *Manuscript M* –, probably the vulgarized version of Tommaso Benci of 1463, was owned by Leonardo[28].

Other great outcomes of Leonardo's conceives about the four Elements are revealed by his anthropological conception. He believed that man, like every other being into Creation, was

the result of a particular blend by the elements Air, Water, Earth, Fire, which would partake him intimately the same processes of transformation, generation and corruption of the universal material that would take place in Nature, according to its own rules («*ragioni*»). This means that the identity between macrocosm-Universe and the microcosm-Mankind cannot be assumed in Leonardo as a literary or rhetorical expedient, an allegorical figure, but as an ontological perspective due to the compliance and connection by man to the same mechanisms which rule the living Whole. The *Manuscript A* contains perhaps the best statement by Leonardo regarding his adherence to the theory of the four Elements as constituent components of human and every beings of Nature, and to the actual identity between the «lesser world» and the «body of the earth»[29]:

> *Man has been called by the ancients a lesser word, and indeed the term is rightly applied, seeing that if is compounded of earth, water, wind and fire, this body of the earth is the same; and as man has within himself bones as a stay and framework for the flesh, so the world has the rocks which are the supports of the eart; as man has within him a pool of blood wherein the lungs as he breathes expand and contract, so the body of the eart has its ocean, which also rises and falls every six hours with the breathing of the world; as from the said pool of blood proceed the veins which spread out their branches throughout the human body, in just the same manner the ocean fills the body of the eart with an infinite number of veins of water. In this body of the earth there is lacking, however, the sinews, and these are absent because sinews are created for the purpose of movement [...], but in all other things man and the world show a great resemblance.*

It should almost be said that Leonardo concerns to get out from the purely analogical degree in the relationship between the macrocosm, or the 'body of the earth', and the microcosm, or the human 'minor world', to establish an actual connection

between the two terms, much more than an analogy, and that the theory of the four Elements provided an answer to this requirement of continuity. This way of conciliation would therefore pass through the physics of the Elements by Aristotelian-scholastic tradition and the physiological mechanisms by Hippocratic and Galenic medicine. Actually, Leonardo purposed to write a treatise, *De figura humana*, of which remains only a sort of list of arguments, where, in the final summarizing part, he would have exposed the study of the human microcosm according to the theory of the four Elements and the four humours. Reflecting an ancient belief that attributed a cosmic and almost sacral reason to the quadripartite form (cardinal points, seasons, times of day, ages of man, etc.), Leonardo planned to explain the «four universal cases of men»[30] dependent by four moods and the balance or imbalance of the Elements. Through these and their couple of qualities – they are remembered: humid and warm (Aria); wet and cold (Water); dry and warm (Fire); dry and cold (Earth) – the argumentation would then have included the «four stories» of man by developing specific psychological features.

Consequently to this anthropological reduction caming from a materialistic point of view, it seems to me that in some passages of the Leonardesque codes we can grasp the solution that he had offered to solve the matter of the immortal soul, without going out from his immanentist and panistical cosmological beliefs. In my opinion, should be referred to this point his statements concerning what he claimed as quintessence (*prima materia*), the subtle pure, incorruptible, perfect substance that Aristotle accounted as constitutive of the celestial spheres and synthetic principle of the four Elements themselves.

According to Leonardo this thin essence would be the substance of the man's soul and therefore, since each Element

tends to go back to its own original place, the quintessential soul 'wishes' to leave the body of man subject to corruption and rejoin the incorruptible substance of the Universe[31]:

> *Now you see that the hope and the desire of returning home and to one's former state is like the moth to the light, and that the man who with constant longing awaits with joy each new spring time, each new summer, each new month and new year – deeming that the things he longs for are ever too late in coming – does not perceive that he is longing for his own destruction. But this desire is the very quintessence, the spirit of the elements, which finding itself imprisoned with the soul is ever longing to return from the human body to its giver. And you must know that this same longing is that quintessence, inseparable from nature, and that man is the image of the world.*

It is harsh to say whether this, which appears to be a mechanistic and materialistic reduction of the soul, may have been influenced more by its revaluation of Stoic-Lucrezian thought, which also played a considerable role within Leonardesque speculation about the point of the form of matter, rather than from the Ficinian and neoplatonic view about the so-called *Spiritus* or *Anima Mundi*. Actually, Leonardo in his researches as an anatomist has never gave up searching a physiological solution to the the rational soul placing, in disagreement with the presumption of the existence of a pneumatic spirit spreading throughout the body, sustained at his time by the Averroist scholars of the Padua university. In fact, he was quite willing to admit that the soul should be placed functionally within the brain[32]:

> *The soul apparently resides in the seat of the judgment, and the judgment apparently resides in the place where all senses meet, which ic called the common sense* [the brain, nA] *and it is not all of it in the whole body as many have believed, but it is all in this part* [...]

Chapter two

Mona Lisa and the theoretical model of the four Elements

The placement of the four Elements within the quadripartition of the *Gioconda*'s landscape is not accidental. It corresponds to the typical schematic configuration that was made up over time based on the physical features, the laboratory performances and the hypothetical properties attributed to them.

The collocation within the landscape of the Fire in lower and the Water in upper side could seemingly gainsay the cosmological alignment of the Elements' spheres by the Aristotelian tradition, also shared by Leonardo, which figured out them arranged in order, according to their own specific weight, starting from the center of the earth; but we should take in account again that he had the awareness that the Elements never appeared in nature in their own pure state, so that every being was the result of a particular composition of them, due to the action of the sun and the moving stars, such as to determine their own specific physical (mass, density, volume, etc.) and functional (elasticity, strength, shape, etc.) features. This idea would explains the differences among similar beings: in theory, for instance, the odds among minerals or rocks would be due to particular amount of the Earth element jointed with the other Elements; or the most or lower flexibility of some woods would be caused by the greater or lesser presence in their composition by Air's particles within their pores[33].

It should also be remembered that Leonardo, in a certain autonomy from Aristotelian speculation, was aware that the gravitation of a body was conditioned by its particular composition of the Elements, according to their respective density, but even by its own physical state. For example, the state of condensation induced by the cold would allow Water to concen-

trate elementary masses in the frozen form, such as to exceed its sphere and appear as ice or snow onto the earth surface with notable weight; even large quantities of massified elemental Fire could have, in theory, remarkable volume, density and weight, such that they can be compared to the solid forms of Earth: so it would occur precisely in metal-bearing rocks or in effusive formations. The position of the volcanic eruption in the lower side of the *Mona Lisa* landscape, therefore, is perfectly consistent with Leonardo's choice to depict the element Fire not abstractly, but in one of the forms of the 'mixed' beings which would be found in nature, as precisely the lava rocks, in which a massive and heavy consistency of Fire and Earth would be such as not to contradict the presuppositions of the Aristotelian physics that established the sphere of Fire above any other.

The placement of the four Elements conceived by Leonardo behind the sitter is neither in contradiction with the most common theoretical and graphic descriptions that the culture of his time worked out on this subject. In particular, the alchemy theorists, who took their doctrinal foundations of their practice namely from the speculations of the usually accepted philosophers of nature, excelled at elaborating over the centuries some effective graphic representations, capable to synthesize the complex reciprocal relations among the four Elements, the theoretical

FIG. 7 – *Oxford, St John's College, Manuscript MS 17, f. 7v.*

FIG. 8

doctrinal contents and the operational indications relative to them (**FIG. 7**). It is often found in the treatises of alchemy a square figure with its vertices occupied by the symbols or notations of the four Elements, within which there is a second concentric square, rotated 45° with respect to the first, corresponding to the four fundamental physical qualities of the Elements: the wet, the cold, the dry, the heat. As a good exemplification of this figurative model, that has got a large number of variants since the Middle Ages, we can take in account a representation depicted in the *Dissertatio de Arte Combinatoria* (1666) by G.W. von Leibniz (**FIG. 8**).

The ancient emblem subtend the assumption of the *coniuctio oppositorum* between the Elements which is often invoked in alchemical practice to obtain the *reductio ad unum*, i.e., the restoration of the *prima materia* or quintessence (*ether* for Aristotle), an incorruptible, eternal, undifferentiated substance, the material that the ancient and medieval tradition, as seen before, believed constitutive of the celestial spheres – but also of all the beings living within the sublunar world, although in the latter the quintessence were split into the Elements quadrisomy –, whose handling was alleged as necessary to obtain the *lapis philosophorum*.

This synthetic scheme, which is based on affinities (*combinationes*) and opposites (*contraria*), is what I suggest to overlay upon the *Mona Lisa* landscape (**FIG. 9**). In this way one would find the Air (on our left) and Water (on the right) elements in the upper part of the picture, and in the lower part the Fire and the Earth: thus, the Elements would be positioned at the vertices of the outer square, in contiguous succession according to their

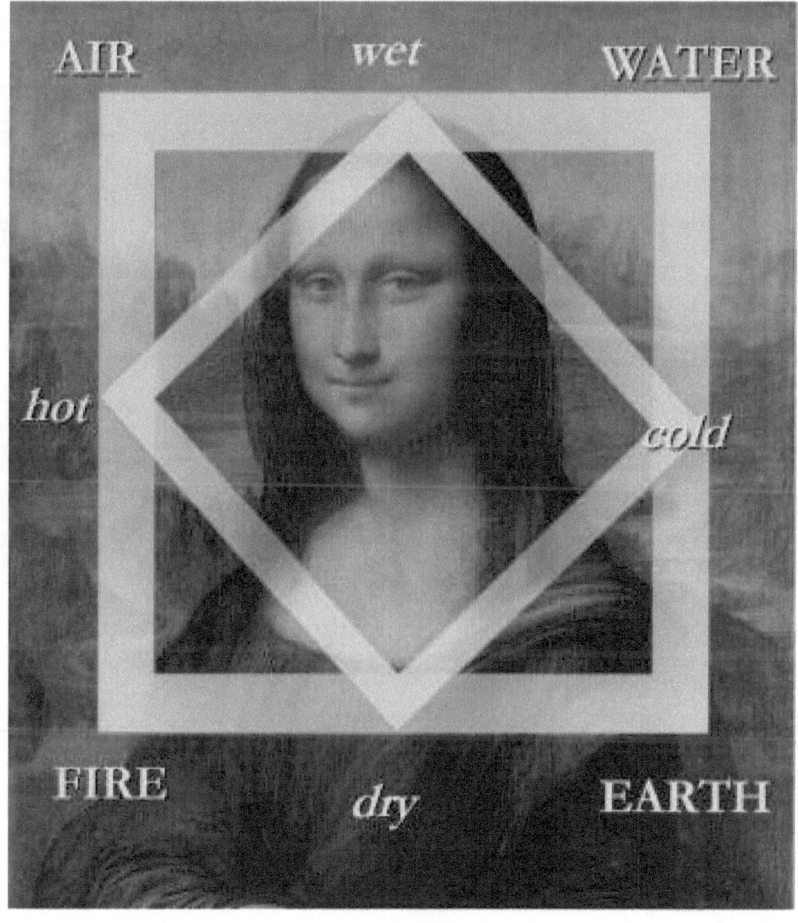

FIG. 9

mutual affinity (*combinationes*): the Air between Fire and Water; the Water between the Air and the Earth; the Earth between Water and Fire; the Fire between the Earth and the Air. The *oppositiones* or *contraria* Fire-Water (hot-cold) and Earth-Air (dry-wet) would instead be placed at the vertices of the internal diagonals of the square scheme (*quadratio*). The same criterion could be applied to the internal polygon, whose vertices are occupied by the four fundamental physical properties of matter according to Aristotelian-scholastic physics: the cold, the dry, the hot and the humid, also arranged one close to another according to their mutual *affinitates*, and in a diagonal sense for their respective *oppositiones* (cold-hot; wet-dry). In this way each Element is placed in balance between two neighboring properties and this points that each of them is featured as a merge by two different and alike qualities: Water with damp and cold, the Earth with cold and the dry, the Fire with the dry and the hot, the Air with the heat and the damp. By this scheme we can deduce that the feature of the damp is shared by Air and Water, the cold by Water and Earth, the dryness by Earth and Fire, the heat by Fire and Air.

The physical properties (cold - dry - hot - wet) pointed by such a scheme of the four Elements in the innermost square suggest for each case the specific feature to be subtracted or added to obtain a given change of state: for example, wishing the transformation of a matter from fluid (Water) to solid (Earth) state we cross the cold (*frigiditas*), namely it requires a cooling or freezing the substance, and so on.

Taking in account the aforementioned location of the four Elements in the landscape beyond the sitter, a 'sexed' two-part division is remarked in the field painting, due to the arrangement by the two ones traditionally believed as masculine, fixed and warm, namely the Air and the Fire, to the left of the pain-

ting (with respect to the observer), and the feminine, mobile ones, namely Water and Earth, to the right. Given the close correlation between the sitter and the landscape, this scheme could somehow offer an argument in favor of everyone invokes an androgynous feature to the depicted central figure, supposed for half a woman and half a man, but sometimes held to be imaginatively a feminized self-portrait by Leonardo himself or by Salaì, due to their alleged homosexuality. Personally I am not so willing to agree to such a deduction: the copies, the instrumental proofs, even the most prosaic versions of the *Monna Vanna*, undeniably convey the image of a real woman[34]; even if one wishes to admit to Leonardo a tendency for his own sex, the necessary connection with androgyny it is harsh to be recognized. Moreover I deny that he wanted to represent somehow himself because of his declared contempt to the self-portraiting, so I would rather abide by the symbolic reasons coming from the scheme of the four Elements, according to their division into masculine and feminine.

Therefore, if one wish to appeal to this kind of argumentation at any cost, I suggest preferably a comparison with the figures of the alchemical *Rebis*, the androgynous emblem that denotes the *coniuctio oppositorum* between the alchemical Sulfur and Mercury[35], the two components, respectively male and feminine, which, according to the included notes in the forth book of *Meteorologica* by Aristotle and recalled by the scholastic authors (for example, the *De Mineralibus* by Albertus Magnus, the *Summa perfectionis* by Paul of Taranto), would be constitutive of all metals and, in particular, of gold and silver, when they are merged themselves in a rare perfect balance. Sulfur and Mercury, not to be confused with the common elements, would in turn be a blend of a couple of Elements according to their respective masculine (Air, Fire) and feminine (Water, Earth) nature, so that

the *Rebis* emblem (from latin *re-bis*, the double thing), which includes jointly masculine and feminine, solar and lunar features, all clearly distinct but closely united, points out the union of the Elements[36]. The *Rebis* is a very ancient *exemplum* that appears in its own features already at the beginning of the fifteenth century in the early samples of Latin alchemical iconography, as found in the *Book of the Holy Trinity* (1415-19; **FIG. 10**) or in the *Aurora consurgens* (first quarter of the XV century, **FIG. 11**) and shows, in numerous variants, an androgynous body, mono or bicephalous, or a body fusion by two human beings, one male and the other female, to which many other typical attributes from the alchemical symbolism are connected, even though they always refer to the notion of *the coniuctio oppositorum*, the final stage of the alchemical work in which the merger between Sulfur and Mercury would take place – therefore, also among the four Elements – within the so-called *lapis philosophorum*.

FIG. 10 FIG. 11

Leonardo knew very well the alchemical emblem of the *Rebis*. He reproduced it in a *folio*, now preserved in Oxford (**FIG. 12**)[37], in a very humanized shape, though perfectly fitting to the typical model of the alchemic tradition. In this image of *reductio ad unum* from a 'double' principle Leonardo borrowed the pattern of the alchemical androgyne, which means the *coniuctio oppositorum* between the Sulfur-male and the Mercury-feminine, to point out a divergence between opposite moral tensions, namely the antinomy between pleasure and pain. The meaning is explained by the captions at the bottom: in the one close to the

FIG. 12

androgynous' feets one reads the words 'gold' («*oro*») and 'mud' («*fango*») to denote an utter value dichotomy between two opposite things, such as gold and the mud, and, therefore, between the male and the female beings of the same Leonardesque dra-

wing. But the sense of allegory is clarified by the maximal moralistic, which I presume was common at his time, reported by Leonardo even further below[38]:

If you take Pleasure know that he has behind him one who will deal you Tribulation and Repentance.

With these words it seems therefore that the Vinci genius exhorts to modesty and moderation, warning about the glories and worldly pleasures, behind which rivalries and disappointments would be concealed. Despite the moralistic meaning, what is important to remark for our subject is precisely the figurative model of the alchemical 'double' that Leonardo seems how to be able to thoroughly manage and adapt to his allegorical compositions, demonstrating also his knowledge about the conceptual and communicative assumptions of this discipline.

If, in conclusion, we claim to invoke at all costs an androgynous feature into the two halves of the *Gioconda* composition and into the face of *Mona Lisa* herself, then the *Rebis* model can be effectively evoked in relation to the renaissance knowledge about the structure of the matter, which leads to identify in the landscape beyond the balcony a symbolic division between the masculine Elements on the left (Air, Fire) and the feminine (Water, Earth) on the right, contrary to each other.

The contiguity two by two in the *quadratio* by the Elements sets in the *Gioconda* landscape a circular procedural path that point out the state passages and the consequent operations to transform one element to another; this development is generally stated in the alchemical lexicon and iconography as the *Wheel of the Elements* and other similar ones. The emblem of the *Ouroboros*, the snake biting its tail, which had been very widespread among the alchemists, actually means the incessant circular

transformation of the Elements within the conservative unit of the cosmic All-One (ἐν τὸ πᾶν). The assumption of the 'rotation' of the Elements was deducted on the theses by Aristotle and the medieval scholastics that, due to the alleged incessant motion of corruption and the generation by the matter, had declared possible the transformation of one element to the other by managing its accidental properties; but, before to get transmuting itself into its opposite one, any Element first has to pass through an intermediate one and its own physical state, performing a 'circular' path as pointed out by the distributional chart of the four Elements. For example, to convert Air into Earth one should pass through Water and so, theoretically, a gaseous substance to be solidified should first be liquefied. I suggest to roll by the *Wheel of Elements* into the *Gioconda* clockwise, without stopping; thus, this following circular sequence amongst the four Elements is gained:

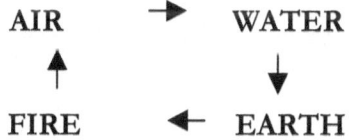

corresponding to their own status changes:

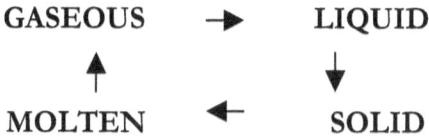

and their respective laboratory procedures that would cause the transmutation from one Element to another:

Chapter two

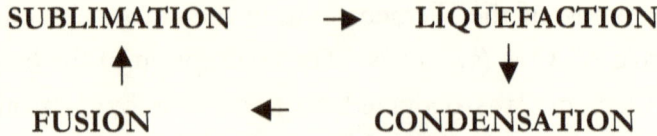

The four Elements and the Leonardo's theory of colours

The greatest consequences following the acceptance of the theory of the four Elements by Leonardo can be found, in my opinion, just in the scope mostly beloved to him, the painting, examining his very personal conception of colours. Some statements by his *Treatise on painting* suggest that Leonardo bestowed to each Element a very specific colour, corresponding to its own accidental features as result by the solicitation of light rays: yellow for the Earth, green for Water, blue for the Air, red for the Fire[39]:

227 – Of the Colours produced by the Mixture of other Colours, called secondary Colours.

The first of all simple colours is white, though philosophers will not acknowledge either white or black to be colours; because the first is the cause, or the receiver of colours, the other totally deprived of them. But as painters cannot do without either, we shall place them among the others; and according to this order of things, white will be the first, yellow the second, green the third, blue the fourth, red the fifth, and black the sixth. We shall set down white for the representative of light, without which no colour can be seen; yellow for the earth; green for water; blue for air; red for fire; and black for total darkness.

It could be argued that the dye luminous intensity, being related to the close correspondence between colours and the four

Elements, would vary depend by the greater or lesser density of its relative Element: this consequence can be deduced from the theoretical formulation of the Leonardesque 'aerial perspective', for which the Air, very transparent in itself, actually displays its typical blue color, due to the progressive presence of water masses in the gaseous state, which even cause the variance of the chromatic gradation[40]:

292. – From what Cause the Azure of the Air proceeds.

The azure of the sky is produced by the transparent body of the air, illumined by the sun, and interposed between the darkness of the expanse above, and the earth below. The air in itself has no quality of smell, taste, or colour, but is easily impregnated with the quality of other matter surrounding it; and will appear bluer in proportion to the darkness of the space behind it, as may be observed against the shady sides of mountains, which are darker than any other object. In this instance the air appears of the most beautiful azure; while on the other side, that receives the light, it shows through that more of the natural colour of the mountain.

The gradual density of the Air element, as noticed, in which water vapor is fidgetting, progressively 'azures' the colours of the landscape details, according to their lesser or larger distance from the foreground, adding to them its own dye gradation[41]:

289. – Of the Change observable in the fame Colour, according to its Distance from the Eye.

Among several colours of the same nature, that which is the nearest to the eye will alter the least; because the air which interposes between the eye and the object seen, envelopes, in some measure, that the object. If the air, which interposes, be in great quantity, the object seen will be strongly tinged with the colour of that air; but if the air be thin, then the view of that object, and its colour, will be very little obstructed.

This result, which can also be realized by the common experience, reproduced into painting landscape backgrounds, creates a perception of great perspective depth. Let us still consider some statements from Leonardesque *Treatise on painting*[42]:

284. – Of the Perspective of Colours.

The air will participate less of the azure of the sky, in proportion as it comes nearer to the horizon, as it is proved by the third and ninth proposition, that pure and subtile bodies (such as compose the air) will be less illuminated by the sun than there of thicker and grosser substance: and as it is certain that the air which is remote from the earth, is thinner than that which is near it, it will follow, that the latter will be more impregnated with the rays of the sun, which giving light at the same time to an infinity of atoms floating in this air, renders it more sensible to the eye. So that the air will appear lighter towards the horizon, and darker as well as bluer in looking up to the sky; because there is more of the thick air between our eyes and the horizon, than between our eyes and that part of the sky above our heads.

300. Of the Colour of objects remote from the Eye.

The air tinges objects with its own colour more or less in proportion to the quantity of intervening air between it and the eye, so that a dark object at the distance of two miles (or a density of air equal to such distance), will be more tinged with its colour than if only one mile distant.

As a greatest example of applying of Leonardo's theory about the colours and luminescence of things we can assume the two versions of the *Virgin of the rocks*, in which the massive density of the Earth element, constituting the solid state of matter, bestows the dark brown colour to the rock formations placed in the foreground due to the strengthening of the characteristic yellow of this Element; but this nuance becomes progressively clearer through the rocks in the distance thanks to the

gradual interposition of the Air, which merges its own blue, typical of this aeriform material, to their earthly colour, according to its increasing density (**FIG. 13**).

Theoretically, in all 'mixed' beings there should be a summation of the typical colours of each Elements that compose them, determining their particular gradation, in relation to their proportion and density. For instance, the green color of the arboreal leaves, which would be made by a combination amongst parts of solid Earth, and large quantities of Air (which cause their lightness and transparency), would be the result of the mixture of both typical elementary colours, respectively of the «simple» (namely primary, according to the language of the Vincian) yellow, with the blue, as also the experience of the amalgamation of the two colors actually proves[43]:

FIG. 13

248. – General Remarks on Colours.

Blue and green are not simple colours in their nature, for blue is composed of light and darkness; such is the azure of the sky, viz. perfect black and perfect white. Green is composed of a simple and a mixed colour, being produced by blue and yellow.

If these considerations of mine had grasped Leonardo's conceptual core about the origin and composition of colours, one would touch the vertex of that scientific and truthful nature

of painting invoked forcefully in his *Treatise on painting*[44]:

How he who despises painting has no love for the philosophy in nature.

If you despises painting, which is the sole imitator of all visible works of nature, it is certain that you will be despising a subtle invention which philosophical and ingenious speculation takes as its theme all the various kinds of forms, airs, scenes, plants, animals, grasses and flowers, which are surrounded by light anch shade. And this truly is a science and the true-born daughter od nature, since painting is the offspring of nature. But in order to speak more correctly we may call it the grandchild of nature; for all visible things derive their existence from nature, and from these same things is born painting. So therefore we may justly speak of it as the grandchild of nature and as related to God Himself.

So, this is a kind of painting which, by renouncing to the chromatic conventions coming from pre-constituted iconographical models, symbolic abstraction, or the whim of personal expression, relies on the 'grammar' of the impersonal and objective laws of Nature on genesis of colours, giving visible form to the intrinsic truth of its mechanisms and its intimate structure.

To sum up, it is clear at this point that the relationships between the figurative model of the *Gioconda*, the theory of the four Elements and the Leonardesque conception of the colour nature, are much tighter than they seem at glance. These connections, as we noticed, are substantially hold by the juxtaposition of the emblematic gradations of Water, Air, Earth, and Fire in each quarter of the landscape relating to them; this placement matches the ancient symbolic schemes that sum up the 'reasons' («*ragioni*») of the quadripartite structure of matter. Therefore, assuming the above-mentioned distribution of the four Elements, we first note the typical reddish colour of the Fire element in the depiction of the volcanic eruption, lower left with

respect to the observer. Beside it, the dominant ocher and brown colours of the landscape quarter featured by the bridge establish a relationship with the Earth element. Rather different are the cases of the Air and Water elements, whose emblematic colours are displayed by a same blue dye, due to the aerial perspective that likewise 'azures' their allegorical features, being placed within the landscape at a great distance from the foreground.

Perhaps it is also thanks to these reasons that, rightly, the *Gioconda* is celebrated as the supreme synthesis of Leonardo's 'scientific' painting.

Leonardo and Alchemy

The presence of a symbolism related to the theory of the four Elements into *Mona Lisa* and the great rely on this belief among natural scientific, medical, physical, and finally also in painting scopes by Leonardo, at first glance would place the painter on the same level as that of alchemists. The legend of a Leonardo initiate into the alleged 'mysteries' of the transmutative art has often been invoked within the popular literature, but has been definitely neglected in the academic context, unless some pioneering statements argued recently by Ladislao Reti, Cesare Vasoli and Giacomo Maria Prati, who worthily studied closely, without any preclusion, the relationship between the painter of *Mona Lisa* and the transmutative discipline, thus resizing the idea of Leonardo as an initiate, esotericist and alchemist[45]. They began to evaluate his authentic thought and to recover his approach to natural phenomena as a proto-chemist, rather than as an alchemist, having actually acquired that Leo-

nardo certainly has experience of manipulating the elements, approached the practice of the Great Work, but definitively renounced to pursue the mirage of the *philosopher's stone* or the *elixir*[46], laying, on the contrary, the groundwork for the modern chemistry. This matter certainly deserves a specific treatment, and yet it is worth facing it *en passant* in these notes about *Mona Lisa* and the theory of the four Elements in order not to continue to generate false assumptions, without claiming to exhaust such a complex topic.

The Leonardo legend as an alchemist is essentially based on some misunderstandings and prejudices.

Some of them are brought by today error that believes the alchemical practice, mind you, of the contemporary time to the Vinci painter, was strictly distincted from the knowledge that we would define today 'scientific', completely detached from the reality of current life and, therefore, marginalized, being realized as a kind of magic, an activity based on mysterious practices and on an esoteric wisdom reserved for a few initiates. Studies that recently have flourished in a detached way from any apologetic or derogatory purposes tend to demonstrate the contrary: alchemy was not only practiced at all levels in the light of the sun, even officially among the noble courts or inside the monasteries, but moreover it was supported exactly by the same theories about the origin and the manipulation of the Elements that Medieval and Renaissance scholars of natural sciences assumed from the Aristotelian and scholastic physics. Therefore, alchemy did not hold to knowledge other than any coeval discipline, but if anything it drew its consequences independently within practical and applicative scopes. The Great Work still appeared in the early sixteenth century, in my opinion, essentially as a real proto-chemistry with operational and laboratory features, carried out with procedures and objectives shared also by the me-

dical discipline and crafts (glassware, metallurgy, etc.). It was still far from the truly magical, mysterious and esoteric drift that it took only after the collapse of the theoretical groundworks on which it was based, as a consequence of the crisis of the *auctoritas* of ancient wisdom and cosmology, which took place around the middle of the sixteenth century with the advent of modern scientific thought, chemistry and pharmacopoeia.

The alchemists themselves concurred to create this prejudice: unfortunately, they could not avoid spreading the perception within the collective imagination that they exercised magical arts. This feeling was certainly sparked, among other ones, by the circumspective and prudent habits that the alchemists had always adopted for their own safety, in order to preserve themselves by the pressures and threats exercised by someone, eager to force them to their own service to get handy wealth and the wished pro-longevity. The self-defensing behavior had consequently led the alchemists, since the origins of the discipline, to obscure thir own communicative language, to adopt tools for the encryption of thought, to choice to operate in secrecy and in the initiatory discipleship. These measures, added to the perception that the alchemists gave of themselves as manipulators of substances and metals, to the *de facto* failure of the declared objectives by the discipline, and to the unavoidable falsifications carried out by ill-intentioned people, had motivated suspicions and mistrustings towards alchemists for a long time and confused their proto-chemical activity with magic practices or mere fraudulence. Most of official prohibitions and bans that have studded the history of Western alchemy from antiquity to the late fifteenth century show that the charges claimed against Great Work operators were based on worries regarding the maintenance of monetary and economic balance, the public order and the suppression of frauds, but did not concern theoreti-

cal contents of the discipline at all[47].

It is good to keep in mind that, at the time of Leonardo, the *exploit* of the Hermetic and esoteric searches, trigged by the recovery and the study of the syncretistic *Corpus Hermeticum* by Hermes Trismegistus, moreover a patrimony whose the 'adepts' of the Great Work could boast first as heirs, discovering a heterodox wisdom tradition held to be (erroneously) reliable and authentic, had fully legitimized the doctrinal assumptions of the alchemistry practice. Also favored by the *studia humanitatis* and the new investigative habit towards natural phenomena, the following reception at the higher levels of the debated *quæstio de alchimia* did not tend to deny the theoretical contents of the *Crisopeia*, which were shared by the contemporary scientists, but rather to discuss its convenience and feasibility, detecting at once the 'true' from the 'false' alchemy, the first in the hands of honest people, correctly informed about the mechanisms of Nature, the last practiced by forgers and louts (the so-called 'blowers', dubbed in this way in a derogatory sense because of their habit of blowing continuously through the bellows into the alchemical ovens, the *athanors*, without obtaining any result)[48].

Therefore, the certainty that Leonardo relied actually in the Aristotelian theory of the four Elements, shared by both the alchemists and his contemporary medieval naturalists, which engenders a lot of confusion in today mind, obscured by modern opinion that this theory has a magical ground and hastily dismisses alchemy as a discipline akin to magic, then it does not appear sufficient to admit *sic et simpliciter* his adherence to the transmutative discipline.

Another misconception that led to the legend of Leonardo as alchemist came from perception that his contemporaries had of him as a wise man who owned the secrets of Nature, a philosopher-magician, a manipulator of the Elements, bewitching

conversationalist by an independent and nonconformist spirit. A reputation that Leonardo gained during his life because of his majestic bearing, his unusual beauty, his free thought outside the common patterns, his independent way of interpreting the secrets of Nature, his vegetarian habit and, even, his original handwriting that was arousing astonishment and even bewilderment[49]. Owing to his uncommon intellectual aptitudes, Pompeo Gaurico in *De Sculptura* (1504) compared him to Archimedes, whereas Giovanni Nesi and others among his contemporaries assimilated him to Pythagoras, Plato and Aristotle[50]. Despite a charge of inconclusiveness, even Vasari bestowed Leonardo by a superhuman and 'divine' spirit[51]:

> *The richest gifts are occasionally seen to be showered, as by celestial influence, on certain human beings, nay, they some times supernaturally and marvellously congregate in one sole person; beauty, grace, and talent being united in such a manner, that to whatever the man thus favoured may turn himself, his every action is so divine as to leave all other men far behind him, and manifestly to prove that he has been specially endowed by the hand of God himself, and has not obtained his pre-eminence by human teaching, or the power of man. [...] Leonardo was in all things so highly favoured by nature, that to whatever he turned his thoughts, mind, and spirit, he gave proof in all of such admirable power and perfection, that whatever he did bore an impress of harmony, truthfulness, goodness, sweet ness and grace, wherein no other man could ever equal him.*

It is a such a kind of fame and memory that Benvenuto Cellini, in his *Discorso dell'architettura* (1568), collected on the person of Leonardo from the statements by Francis I of France, who, still at a distance of almost twenty years from his death, «did not believe never, that another man was born in the world so supreme wise, that he knew as much as Lionardo, not only of

sculpture, painting and architecture, since he was a great philosopher»[52], so much so that he could not separate himself from him, having been fascinated and enchanted by the wisdom of his conversations as if he were in the presence of a prodigious magician[53].

But in the last nineteenth century the personality of the artist has further obscured by a Faustian and supernatural aura that definitively enhanced Leonardo's *legenda negra* as a philosopher-magician, a wise agnostic, enlightened connoisseur of all the secrets of Nature. The reveries of the Russian novelist Dmitry Merežkovskij (*Resurrection of gods. Leonardo da Vinci*, 1900) and the extravagant claims by Paul Valéry have unfortunately contributed specially to getting Leonardo a prosaic subject suited to the 'mystery's literature' that still today does not disappear.

Therefore, in response to the question about Leonardo as alchemist, the answer can only be extremely dubious, if not entirely negative. It is the author of the *Mona Lisa* himself who denies such a rumor, when, in his *Treatise on painting*, at the end of a demonstration on optical physics, for the truth rather arid and extremely technical, he states[54]:

> *Here the adversary says that not much wisdom is needed, because the practice of depicting from life is enough; to that one replies that there is no more deceptive thing than trusting one's own judgment without any reason, as the experience, enemy of the alchemists, necromancers and of other simple minds, always proves.*

The blame that Leonardo charges to the alchemists is therefore that of being gullible, «simple minds», who trust only their own or others' practice, the personal observation or «judgment» in principle, without looking for the laws of the Nature, called by him again as «reasons» («*ragioni*»), which underlie the pheno-

mena that fall under our sight. In his writings Leonardo stated very explicitly such a reproach[55]:

19. Of the mistakes made by those who practise without knowledge.

Those who are in love with practice without knowledge are like the sailor who gets into a ship without rudder or compass and whop never can be certain whether he is going.

Unlike them, Leonardo, who boasted of being an 'not literate' man, and refused to get his knowledge through the ancient writers – though it is certain that from 1494 he began to learn the Latin language by himself and that he had got anyway vulgarizations from which most of the ancient and medieval texts he could draw – he trusted the results by «experience», that is the observation and reproduction of particular phenomena to deduce the universal laws, thus giving the way to the modern scientific methodology[56]:

But first I will do some experiences, before I proceed further, and then by the reason I will go to explain, because the experience is forced to operate in its way.
And this is the true rule, that the scholars of natural effects must follow, and that nature begins from rules and ends in experiences, we must follow it in reverse [...], from experience and then deducing rules.

A blame by the same tone is repeated in the *Codex Forster II* (1495-97) in which he places alchemists on the same level with the deluded seekers of perpetual motion, who trust only the practical experience by vain attempts, without having understood the physical laws of Nature that get this research a mere utopia[57]:

Oh! Speculators on perpetual motion how many vain projects of the like

character you have created! Go and be the companions of the searchers for gold.

Even those who practice black magic, or 'necromancy', who delude themselves that they govern Nature through the manipulation of spiritual entities, are mercilessly condemned for not understanding, according to Leonardo, the mechanical laws that rule Creation, in which there is no evidence about the existence of such incorporeal beings. Therefore, even to those who practice black magic Leonardo expresses some blames without appeal[58]:

> *Of all human opinions that is to be reputed the most foolish which deals with the belief in Necromancy, the sister of Alchemy, which gives birth to simple and natural things. But it is all the more worthy of reprehension than alchemy, because it brings forth nothing but what is like itself, that is, lies; this does not happen in Alchemy which deals with simple products of nature and whose function cannot be exercised by nature itself, because it has no organic instruments with which it can work, as men do by means of their hands, who have produced, for instance, glass &c. but this Necromancy the flag and flying banner, blown by the winds, is the guide of the stupid crowd which is constantly witness to the dazzling and endless effects of this art; and there are books full, declaring that enchantments and spirits can work and speak without tongues and without organic instruments – without which it is impossible to speak – and can carry heaviest weights and raise storms and rain; and that men can beturned into cats and wolves and other beasts, although indeed it is those who affirm these things who first became beasts.*

Despite these blames, Leonardo seems to look kindly at the alchemists, on whom he bestowed a constructive function, insofar as they have historically concurred to technical progress and to the achievement of practical gains, such as in the glassware and other useful craftsmanship, and have foresaken to pursue

the utopical *lapis philosophorum*[59]:

> *Nor is this true in the case of any other sense; for these are concerned only with such things as nature is continually producing, and she does not change the ordinary kinds of the things which she creates in the same way that from time to time the things are changed which have been created by man; and indeed man is nature's chiefest instrument, because nature is concerned only with the production of elementary things, but man from these elementary things produces an infinite number of compounds, although he has no power to create any natural thing exept another like himself, that is his children. And of this the old alchemists will serve as my witness, who have never either by chance or deliberate experiment succeeded in creating the smallest thing which can be created by nature; and indeed this generation deserves unmeasured praises for th service-ableness of the things which they have invented for the use of man, and would deserve them even more if they had not been the inventors of noxious things like poisons and the similar things which destroy the life or the intellect; but they are not exempt from blame in that by much study and experiment they are seeking to create, not, indeed, the meanest of nature's products, but the most excellent, namely gold, which is begotten of the sun inasmuch as it has more resemblance to it than to anything else that is, and no created thing is more enduring than this gold.*

These statements also explain the judgment of groundlessness on the alchemic practice by Leonardo. He believed the impossibility of reaching the point of manipulating, creating or duplicating the matters of the primary elements, the so-called «simples», though he attributes to man the noble and superior task of being able to produce artificial compounds and substances for his own usefulness and which are not be commonly found in nature. Thus the alchemists are deserving of so many praises, or 'infinite lauds', not only because they fully exercise the autonomous manipulative capacity reserved exclusively to mankind, but also because they unintentionally display, with the

limits of their action, the existence of a insurmountable border that Nature opposes to its activity. How up-to-date is this warning by Leonardo so that scientists and technicians do not overcome the restrictions imposed by Nature and subject themselves to an ethically respectful conduct according to its rules or «*ragioni*»!

Leonardo's reproach to the alchemists for their claim to overcome the limits imposed by Nature is based on both speculative and experimental reasons: after analyzing the gold mines where the precious metal seems to succeed in transmuting the close rocks by contact, theoretically recognizing to the gold metal the power to transform what it touches, giving essentially right on this point to the alchemical tradition – the virtue of 'goldening' (aurification) every 'vile' metal by the incorruptible *lapis* proclaimed by the followers of the Great Work –, he declares the impossibility of reproducing this generative phenomenon by Man[60]:

> *If, however, insensate avarice should drive you into such error, why do you not go to the mines where nature produces this gold, and there become her disciple? She will completely cure you of your folly by showing you that nothing which you employ in your furnace will be numbered among the things which she employs in order to produce this gold. For there is there no quicksilver, no sulphur of any kind, no fire nor other heat than that od nature giving live to our world; and she will show you the veins of the gold spreading through the stone, - the bleu lapis lazuli, whose colour is unaffected by the power of the fire. And consider carefully this ramification of the gold, and you will see that the extremities of it are continually expanding in slow movement, transmuting into gold whatever they come in contact with; and note that therein is a living organism which it is not within your power to produce.*

Leonardo's statements on the limits of alchemical experi-

mentation seem to me to re-propose the analogous confutation expressed by the Aristotelian Avicenna who declared, in his famous claim («*Sciant artifices*») included in his *De congelatione et conglutinatione lapidum* (translation of *Kitab al-Shifa*), well known and debated by the alchemy writers, the impossibility of transmuting the substance of the Elements, because the *mutationes* that can be operated on matter transform, in the Aristotelian sense, only the accidental consistency of the form, but neither the form itself, nor its substance[61]:

> *The artificers do similar operations to the natural ones; and although the artificial operations are not the same as those by nature nor can it be imitated with certainty, it is believed that the composition of natural things occurs in this way or in a way very similar to it. Nevertheless, artifice is weaker than nature and fails to imitate, however much it attempt harshly.*
> *But let the alchemists know that they cannot transmute the species of things. However they can produce a certain resemblance and dye the red by yellow, so that it looks like gold, and dye the white by the color they want, until it looks very much like gold or copper.*
> *They can also clean the impurities of lead, but it will always remain lead, although it looks like silver and in it some extraneous qualities are clear, to the point of deceiving those who confuse salt and ammonia salt.*
> *But I do not believe that it is possible to artificially eliminate the specific differences, and a compound cannot be transformed into the other, since the sensitive features of things are not the differences for which the species are distinguished from each other, but only accidents and quality. The differences of the species are not known: therefore, ignoring what is a difference, how can we know if it has been eliminated, or in which way it is eliminated?*
> *And yet to remove the accidents, such as taste, color, weight (or better to reduce them) is not impossible: but in all cases the proportion amongst substances will not remain the same. In fact, one thing cannot be transformed into another if it is not reduced to the prime material, and only*

> *in this way will it be possible to transform it into something other than before: this, however, is not achieved by mere liquefaction, but some unknowing processes else should be performed.*

To express his praises for the technical achievements and utilitarian advances of the alchemists, but at the same time to blame their alleged power to modify the substance of matter or to manipulate life, Leonardo proves to have got a certain acquaintance with the typical practices, literature and language of the transmutative art, especially since he shared with the *adepts* a large part of the theoretical positions from the common Aristotelian culture. In spite of this, he does not hesitate to refute Aristotle's thesis, included in his *Metereologica* and assumed along centuries as the linchpin principle of alchemy, about the origin of metals due to the variable combination of Mercury and Sulfur, whereas he expressed his own conviction, also opposing the secondary alchemical doctrine on the unique material (the so-called 'sole mercury')[62] which he knew well, that every metal is generated by its own distinct 'seed' which is 'actualitized' (in Aristotelian meaning) by Nature 'vegetative soul'[63]:

> *The false interpreters of nature declare that quicksilver is the common seed of every metal, not remembering that nature varies the seed according to the variety of the things she desires to produce in the world.*

I would not be surprised if Leonardo's ambivalent statements about the Great Work had been conditioned by his personal acquaintances with several contemporary alchemists, some of whom were certainly honest researchers, others much less so. Among the first ones I would certainly include his teacher, Andrea del Verrocchio, who, Vasari recalls, practiced the trasmutatory discipline to emprove the formulation of pigments and

metal casting techniques[64]. Jointly with Verrocchio, I would like to name Caterina Sforza, Duchess of Forlì and nephew of the Moro, mother of Giovanni dalle Bande Nere (1498-1526), certainly known by Leonardo, so much so some scholars suggest, as we have seen, that the *Mona Lisa* might portray her: her own interest in alchemy is testified by the legacy of her laboratory recipe book entitled *Experimentii de la Ecc.ma Sa Caterina da Forlì matre de lo inlux.mo Mr. Giovanni de Medici*, in which we find the teachings by the Forlì alchemist Lodovico Albertini[65].

Different is the case of his two other friends, both addicted to alchemy, whom Leonardo still met in the proteiform workshop of Verrocchio and with whom he established rather significant professional and human relationships: Giovan Francesco Rustici (1475-1554) and the obscure Zoroastro (1462-1520). They could have shown him a sincere and passionate devotion for the trasmutatorial discipline and addressed their curious friend toward this kind of interests.

With the first, the very young Leonardo established a solid friendship during his apprenticeship at Verrocchio's workshop, so that their artistic and human partnership was destined to last over time. In fact, during his second stay in Florence, along the years of the *Gioconda*'s composition, Leonardo helped his recovered friend, sharing the same house of their patron Piero Martelli, to model a *Preaching of the Baptist to a Levite and a Pharisee* in bronze (1511) commissioned by the Merchants' guild. Rustici, who was an alchemy researcher, says Vasari, «also wasted both time and money in attempting to freeze mercury, and this he did, in company with Raffaello Baglioni, a genius of similar character»[66], might have tried to involve his friend and colleague in his own interests in the transmutation practice.

Leonardo's delight in spectacular effects, prestige games and his preference for unconventional and brilliant people had made

him become friend, always during his youthful years at Verrocchio's workshop, with another queer person, self-styled magician, alchemist, inventor and, perhaps, swindler, such Tommaso di Giovanni Masini, who called himself Zoroastro da Peretola[67]. He was welcomed as assistant and pupil by Leonardo, who took him to the Milanese Sforza court in 1482, where Tommaso gained a technical and as a 'magician' job; back together to Florence, he shared as a 'familiar' («*famiglio*») of the Master the unfortunate experimentation on oil colours for the *Battle of Anghiari*, but above all he tested the 'flying machine' designed by Leonardo, launching himself from Monte Ceceri, near Fiesole, in 1505, but getting serious wounds[68].

It seems plausible to me the opinion of Girolamo Calvi, reported by Ladislao Reti[69], according to which the definitely skeptical attitude towards alchemy, astrology and the magic arts evolved in Leonardo only during his first Milanese period (1482-1499), where he perhaps met some astrologers, magicians and alchemists by dubious morality[70].

Leonardo's proficiency in alchemy is demonstrated not only by his personal acquaintances, but also by the knowledge and use of the literary and cultural heritage related to the Great Work. Although it cannot be assumed as an absolute valid evidence to establish the whole consistence of Leonardo's knowledge, who had at his disposal for study the best libraries, the mention of alchemy essays in the lists of his own library can be believed as a proof of his appreciation for the theoretical assumptions of the transmutative discipline. Among them are listed some 'classics' of the alchemic tradition: the already mentioned *Corpus Hermeticum* by Hermes Trismegistus and the Aristotle's *Meteorologica*, but also the *De mineralibus* by Albertus Magnus, the *Opus Maius* by Roger Bacon, the *Liber lucis* by John of Rupescissa, the *Liber canonis quinque medicinæ* by Avicenna, the

Acerba by Cecco d'Ascoli, with others of similar subject, such as a pseudo-Aristotelian *Lapidary*, the *Chyromantica scientia naturalis*, the *De Metheoris* by Albertus Magnus, the books of Aristotle's *Physics* , the *Libellum sex quantitatum* by Al-Kindi[71].

With all above, it is worth highlighting that he employed the typical language of the alchemists to point metals with their respective planets when he needed assuming an habit of secrecy[72], or remembering his claim about gold as «true son of sun»[73], and, reminding his figurative elaboration on the model of the *Rebis*, to convince oneself that Leonardo dealt actually with the iconographic and communicative language of the transmutative discipline.

In essence, even facing the *quæstio de alchimia* Leonardo shows that he has got an open-mindedness and an autonomy of judgment like few of his contemporaries, such that, although he shared with the alchemists the theory of the four Elements and the same beliefs about the composition of matter, although he appreciated the practical results of transmutatory art and its theoretical assumptions, designed *athanors* for distillation and metallurgical experiments, even attended some *adepts*, it allowed to keep himself always skeptical about the capacity of manipulating the substance of the Elements to realize the *philosopher's stone* and held himself at the right equidistance from any excessive involvement with the Great Work[74]. On the other hand, his openness in favor of alchemical practices purposing to combine substances has allowed him to develop the mental *habitus* of the modern chemist, preceding a few decades the evolution that the alchemy itself undertook towards the iatrochemistry and modern chemistry.

This brief *excursus* on the relationship between Leonardo and alchemy and, in passing, magic and esotericism, seemed to me to have been needed in order to get rid of easy speculation

about the alleged esoteric subject of the *Mona Lisa* that so much crowds the *web* and popular literature with the most weird fantasies, and that also my declaration on the presence of the symbolism of the four Elements in the landscape beyond the sitter might wrongly arouse. This declaration, therefore, is not enough to prove the existence in the Louvre wooden panel of a linkage with the alchemical discipline, which Leonardo himself does not seem to follow at all, if anything induces us to strongly reiterate the placement of his thought in the context of the Aristotelian-scholastic speculative tradition, from which he deduced its own meditations about the metamorphism of the matter including in a large part of the *Codex Leicester*.

CHAPTER THREE

MONA NATURE

The 'woman of mystery' finally has got a name and an identity. After initially having the Lisa Gherardini's ones, or no matter of other actually lived woman, she, at the end of Leonardo's career, at the castle of Clos Lucé, had by now only become an ideal sitter for an ideal subject: the Nature.

This theme has been depicted by Leonardo in the so-called *Gioconda* according to the iconographic lexicon of allegories and personifications, in the light of which, in my opinion, all inconsistencies that are found in this atypical portrait, which are the reasons and subjects for infinite novelesque inferences about it, are thoroughly resolved. The allegorical layout in the Louvre wooden panel, which recalls to mind the ancient way – a typical feature of iconographic language – of visualizing complex contents by a combination of images taken suitably from reality, is essentially composed by two elements: the central sitter and the landscape behind it.

As for the first, namely the central figure of a woman, we should take in account the ancient habit of representing a thought, an idea or a concept, personifying it in a female figure.

Giotto, for instance, gave a woman's face and body to the *Virtues* and *Vices* in the figurative base of Scrovegni chapel, Ambrogio Lorenzetti embodied the effects of the *Good Government* and the *Bad Government* in Siena's town hall with as many female personifications, and so even Piero del Pollaiolo and Sandro Botticelli for the *Virtues*, originally painted for the Florentine *Tribunale della Mercanzia*, and so on.

In Leonardo's mind, Nature, by its transformations and its energy, is conceived as a *natura naturans*[1], which generates and creates incessantly from the mutation of the unique matter: it is a creator, is a mother, therefore, is a woman. A mother like Lisa Gherardini, whom Leonardo met during the years of his second Florentine stay, not thanks to the chance of a regular commission for a portrait, but as a mere occasional sitter, as is my firm conviction.

With this face of a woman and of a mother, Leonardo has embodied an unprecedented personification of Nature as Great Mother, renewing the ancestral prototype of this telluric divinity, without relying on the steady iconographic tradition relating to it that from antiquity had lasted to Renaissance through classical mythology and the simbology of gnostic-hermetic culture. An humanistic *Great Mother Nature* who, like a pantheistic goddess[2], a deity without an Olympus, a new secular Virgin Mary, with her gentle smile and magnetic gaze, embodies a laical and sublime *Natura genitrix* that takes care of the One-All and provides to the endless dynamics of generating and corrupting the cosmos.

Then why giving to Nature the appearances of a living woman and not rather renew the models of the ancient divinities related to the Great Mother's worship (e.g., Astarte, Cybele, etc.)? As he renounced the principle of *auctoritas* by the Ancients, proclaiming himself 'not literate' to affirm his full auto-

nomy from any preset truth or that escapes the empiric evidences, so I like to imagine a Leonardo without pre-established iconographic models, independent also with respect to the figurative schemes from classicist or any pictorial tradition else, that would chance being an vacuous repetition of *exempla*, unsuitable to synthetically grasping such a huge and atypical theme as the one he conceived into the Louvre woden panel. In short, a Leonardo who, proposing to set in pictorial shape the same thoughts expressed into his codes, refused to compromise himself with the *auctoritas* of classical divinities, of myths of the past, of fideistic or Christian figurative patterns, and, to evoke Nature by its essence, by its most depth material and non-metaphysical conceptual truth, real and not transcendent, secular and non-cultic, he choosed the necessary way of embodying it in a real woman face.

We should always keep in mind that Leonardo, from the time of his apprenticeship in the Verrocchio's workshop, used – notes Vasari as well – to depict from life, as shown by his extraordinary drawings on drapery, moving figures, facial expressions, which he spread in his codes, and that his habit led him to investigate even the crude reality of the human body in his celebrated anatomical sketchs. One should not even forget his personal disposition, actually very common among the painters of his time, of giving a face by known people to the characters of his own paintings: for example, it is easy to discover the look of Salaì in his late *St. John the Baptist* and in the *Salvator Mundi*. Therefore, when it was a question of giving a human face to Nature, Leonardo preferred to deal with a living body – «*al naturale*» (i.e., from real life), using the language of his contemporaries –, finding in an temporary sitter as Lisa Gherardini the face that matched to the best at that time to his ideal image of *Mona Nature*. And this also clarifies why the woman does not show

any trace of her identity or of her nuptial condition, nor a particularly detailed clothing, nor the signs of her own social *status* or morality, thus disregarding the conventions of current portraiture.

With regard to the second element of the allegory, the landscape, it now seems plain that the theme of Nature was conceived by Leonardo into the *Gioconda* territorial scenery as a metaphor of the four-Elements dynamics, according to the conceptual models coming from the Aristotelian-scholastic culture: from this speculative patrimony the painter declaims, by the geological view that evokes scenarios of impressive cataclysms and enormous triggering forces, the endless motion due to transformation of matter and its elementary forms, according to the ancient principle of continuous corruption and generation.

No one, not even Leonardo himself before, had ever conceived a landscape of such power as that behind *Mona Nature*, renouncing the conventional naturalistic scenarios used as generic filling backgrounds for human subjects. In this case, it is a landscape that I do not hesitate to call apocalyptic, by *day after*, where mountains, lakes, rivers, rocks and even man's works appear destroyed, ruined, shattered by a mighty cataclysm that has totally modified their features. No living being seems to have survived the unleashing of the agents of the territorial mutation in this visionary iconographic transposition by those 'reasons' of the earth crust metamorphosis that Leonardo dealt with in his maturity in the *Codex Leicester* and in his *Deluge*'s drawings at Windsor Castle: πάντα ῥεῖ («Everything flows», says Heraclitus), everything, even the ephemeral man's work meant by the bridge over the river, is undergone to this powerful mechanism of creation and dissolution, is *vanitas*. It is a totally atypical and non-conventional vision where a cosmic vertigo that gets this surreal landscape perhaps the early 'horrid' of painting is revea-

led, a forerunner of the Sublime aesthetics, and even a precursor of the planetary fantasies by modern science fiction.

The Aristotelian dynamics of the four Elements transmutation in the landscape of the *Mona Lisa-Mona Nature* should not be understood, at this point, as a mere erudite, conceptual, proto-scientific declaration, but as the expression, in allegorical way, of the continuous becoming, of the metamorphic essence of matter in its entirety, in its endless and titanic cycle of corruption and generation that nothing and no one can escape.

These meditations recall many of the Leonardesque claims that admit a bitter truth into the Nature: it would sometimes behaves like a merciless and indifferent, titanic and sublime power, as an actual stepmother who orders and disposes everything according to her own laws, regardless of the miserable existence of each being. The theme of mother-stepmother Nature is a very ancient meditative *tòpos*, already argued by Pliny the Elder in the seventh book of his *Naturalis Historia* and taken up extensively in medieval and Renaissance literature (Petrarch, Niccolò da Correggio, Cristoforo Landino), then assumed by Leonardo in a lot of his own concerns, in which he focused on the double temper of Nature, which, in an inscrutable way, behaves in some cases and for some beings as a mother and for others as a stepmother[3]:

> *Here nature appears with many animals to have been rather a cruel stepmother than a mother, and with others not a stepmother, but a most tender mother.*

To the same obscure 'reasons' of Nature, Leonardo also seems to entrust the answer to the questions raised by the so-called 'question of Fortune', which so much engaged intellectually humanists such as Machiavelli and Guicciardini[4]:

Chapter three

Of asses which are beaten.
O neglectful nature, wherefore art thou thus partial, becoming to some of thy children a tender and benignant mother, to others a most cruel and ruthless stepmother? I see thy children given into slavery to others without ever receiving any benefit, and in lieu of any reward for the service they have done for them they are repaid by the severest punishments, and they constantly spend their lives in the service of their oppressor.

And this is how the Great Mother Nature, beyond that caring and smiling parent embodied in Lisa Gherardini's face, shows in the apocalyptic background landscape her dark side by unscrupulous, impersonal stepmother, who is accountable only to the keen logic of her laws, closing, with her double allegorical profile, Leonardo's lay meditation about the deepest 'reasons' of the Universe.

I believe that in the Leonardo's mind the *Gioconda* has always been figured out as *Mona Nature* and never as *Mona Lisa*. The Vasarian comment, in fact, while it is so punctual in specifying some secondary details of the painting, does not relate anything to Leonardo's and his clients purposes about the destination of the portrait, thus this opens to the chance of believing that Lisa Gherardini agreed the proposal to lend herself as a mere model, perhaps thanks to the intermediation by ser Piero, for a 'study of a woman' that in Leonardo's intentions should have always remained as a personal meditation on the subject of *Mater Natura*, almost as if it were be a private pictorial note like his code's drawings. This intentional purpose on the Louvre painting as a studying work or a private exercise, certainly agreed, would have relieved Leonardo from any duty to his model, such as the usual delivery of the portrait, even if it had remained in the state of 'imperfect' draft, as it actually happened for a long time. Freed from any contractual constraint, I believe that Leonardo began to portray his sitter's «head» doubtless during the

first months of 1503, shortly after his arrival in Florence, purposing to carry it out freely. However, having been continually interrupted by the already mentioned biographical reasons and by the very great commission for the *Battle of Anghiari*, the drafting of *Mona Nature* dragged on over the years – however, we should take into account that one of the reasons for its slow running is due in part to the particular painting technique of Leonardo, which earned him the accusation of laziness or extravagance, which is featured by subtle overlapping of oil-painting glazings that required long drying times – up to the late Roman years. At that point I guess that the behests (*«instantie»*) by Giuliano de' Medici urged Leonardo to resume the painting and add the missing part of the landscape and other details of clothing (such as the veil) and the hairstyle that are overlapping to the previous work, so that the allegory of *Mona Nature* could be shown completed, jointly with the other *«tucti perfettissimi»* paintings, at the glance of Cardinal Luigi d'Aragona and his secretary in 1517. It is also unfolds, therefore, why in that meeting Leonardo gave only generic indications about the identity of the sitter he met fourteen years before, actually being her unknown at the chronicles of the time, whereas, if she had been a celebrated woman, it is hard to believe that the artist would have hidden her name.

However one can also accept, although of course I'm personally inclined to my above explained hypothesis, that the portrait of Lisa Gherardini, regularly commissioned by Francesco del Giocondo in 1503, was shortly after forsaken by Leonardo and taken up again during the Roman years, always by *«instantia»* of Giuliano de' Medici, and that this was the chance that led the artist to impress into *Gioconda* his meditations about the identity between Macrocosm and Microcosm, the four-Elements dynamics and the geological transformations that fill up the pages of

his codes. This resumption of the painting would have transformed *in itinere* the subject, from the portrait of *Monna Lisa* Gherardini, to that of *Mona Nature*-Great Mother, partly modifying the face and attributes, and elevating the Louvre masterpiece from the representative level to the allegorical and conceptual one.

Whichever way it happened, the myth of *Mona Nature*, passed to history as *Mona Lisa* or *Gioconda*, began from that time.

NOTES TO CHAPTER ONE

¹ GIUSEPPE PALLANTI, *Monna Lisa. Mulier ingenua*, Florence, 2004; ID., *La vera identità della Gioconda*, Milan, 2006.
² GIORGIO VASARI, JONATHAN FOSTER (ED.), *Lives of the most eminent painters, sculptors and architects*, London, 1871, vol. II, pp. 384 and ff.; GIORGIO VASARI, MAURIZIO MARINI (ED.), *Le vite dei più eccellenti pittori, scultori e architetti*, (orig. ed. Florence, 1550 e 1568), Rome, 2009, pp. 564.
³ About this topic: FRANK ZÖLLNER, *Mona Lisa del Giocondo*, «Gazette des Beaux-Arts» 121(1993), pp. 127 and ff.
⁴ SERGE BRAMLEY, *Leonardo da Vinci artista, scienziato, filosofo*, Milan, 2017², pp. 310-314.
⁵ *Ibi*, p. 315.
⁶ The assumption that the Vasari source is Paolo Giovio or another Lombard scholar is supported, among others, by Marani (PIETRO C. MARANI, *Leonardo la Gioconda*, «Art e dossier», 189(2003), p. 28).
⁷ The acquaintance among del Giocondo couple and Vasari at the time of the editing of his *Lives* (both Lisa Gherardini and her husband Francesco were still alive around 1447), is recognized by Sassoon, Zöllner and also by other scholars as a possible informative source for his commentary about the *Gioconda* (DONALD SASSOON, *Il mistero della Gioconda. La storia di un dipinto attraverso le immagini*, Milan, 2006, p.109; FRANK ZÖLLNER, p. 118).
⁸ MARTIN J. KEMP, GIUSEPPE PALLANTI, *Mona Lisa The people and the painting*, Oxford, 2017, p. 57; PEDRETTI CARLO, *Leonardo & Io*, Milan, 2008, p. 611.
⁹ «*Apelles pictor. Ita Leonardus Vincius facit in omnibus suis picturis, ut est caput Lisæ del Giocondo, et Annæ matris Virginis. Videbimus quid faciet de aula Magni Consilii, de qua re conveniit iam cum Vexillifero 1503 octobris.*» (ANTONIO FORCELLINO, *Leonardo. Genio senza pace*, Bari-Rome, 2016, p. 209; MARTIN J. KEMP, GIUSEPPE PALLANTI, pp. 104 and ff; CARLO PEDRETTI, p. 616).
¹⁰ Zöllner, thanks to other clues, argues that Leonardo begun the portrait between February and March 1503 (FRANK ZÖLLNER, p. 120).
¹¹ «*In uno dei li borghi el Signore con noi andò a vedere messer Lunardo Vinci firentino, vecchio de più de LXX anni, pictore in la età nostra excellentissimo, quale mostrò a sua Signoria Illustrissima tre quatri, uno di una certa donna firentina, facto di naturale ad instantia del quondam Magnifico Iuliano de Medici, l'altro di san Iohanne Baptista giovane, et uno de la Madonna et del figliolo che stan posti in gremmo de sancta Anna, tucti perfettissimi*» (BIBLIOTECA NAZIONALE VITTORIO EMANUELE II DI NAPOLI, *Manoscritto X*, F 28, 10 ottobre 1517; MARTIN J. KEMP, GIUSEPPE

PALLANTI, p. 106 and ff; PIETRO C. MARANI, p. 44).

[12] PIETRO C. MARANI, p. 26; GIUSEPPE PALLANTI 2006, p. 52.

[13] Adolfo Venturi in 1925 proposed to identify the lady of the Louvre with Constance d'Avalos, duchess of Francavilla, on the basis of the black widow's veil she wears, which would compare with the description, written by Enea Irpino in his *Canzoniere* in 1520, of her lost portait painted by Leonardo, where she appeared «under the beautiful black veil». In 1977 Hidemichi Tanaka hypothesized that the *Mona Lisa* were the portrait of Isabella d'Este (1474-1539)(ALBERTO ANGELA, *Gli occhi della Gioconda Il genio di Leonardo raccontato da Monna Lisa*, Milan, 2016, p. 290; PIETRO C. MARANI, p. 28; TANAKA HIDEMICHI, *The second 'Madonna of the Rocks' and the 'Mona Lisa'*, in RAYMOND STITES (ED.), ELIZABETH STITES (ED.), PIERINA CASTIGLIONE (ED.), *The sublimations of Leonardo da Vinci with a translations of the Codex Trivulzianus*, Washinghton1970, pp. 328-338). The hypothesis that *Gioconda* represents Caterina Sforza (1462-1509) is supported by Magdalena Soest (MAGDALENA SOEST, *Caterina Sforza ist Mona Lisa: die Geschichte einer Entdeckung*, Kappelrodeck, 2011). To sum up briefly the other most authoritative interpretations would be mentioned: the identification with Leonardo's mother, Caterina (1436ca-1493), born Lippi and married to Antonio di Piero Buti called *Attaccabriga* (quarrelsome), supported by Freud in one of his famous essays (SIGMUND FREUD, *Eine Kindheitserinnerung des Leonardo da Vinci*, Leipzig-Wien, 1910) and newly proposed by other recent scholars, including Angelo Paratico (ANGELO PARATICO, *Leonardo da Vinci Un intellettuale cinese nel Rinascimento italiano*, Verona, 2017). Others believe that *Mona Lisa* is Leonardo's feminized self-portrait (Lilian Schwartz compared the face of the Louvre with that of the so-called *Vecchione* of the Biblioteca Reale Turin, f. 15571r) (MICHAEL J. GELB, *Pensare come Leonardo. I sette principi del genio*, Milan, 2010³, p. 149) or the portrait of Salaì. About theories that identify *Monna Lisa* with Isabella Gualanda or Pacifica Brandano, you refer to the text and related notes.

[14] Walter Isaacson actually refers about two other theses: a 'romantic' that would reveals a certain emotional or sentimental involvement by Giuliano towards Lisa Gherardini in his youth; and the other related to an alleged remote kinship and acquaintance between them (Lisa's stepmother was a cousin of the future Duke of Nevers). The scholar finally, however, shows the idea that, bringing Leonardo to Rome the portrait of the *Mona Lisa*, Giuliano «could have recognized the potentially universal beauty of the painting and supported its fulfillment by Leonardo» (WALTER ISAACSON, *Leonardo da Vinci*, Milan, 2017, p. 409 and ff).

[15] ALBERTO ANGELA, p. 318; AGOSTINO DE SANTI ABATI, *I segreti codici della Gioconda*, Montevarchi, 2015; COSTANTINO D'ORAZIO, *Leonardo segreto*, Milan, 2014, p. 160; ROBERTO ZAPPERI, *Monna Lisa addio: la vera storia della*

Gioconda, Florence, 2012.

[16] «*Lionardo di ser Piero da Vinci ciptadino fiorentino [...] Ritrasse al naturale Piero Francesco del Giocondo*» (BIBLIOTECA NAZIONALE CENTRALE OF FLORENCE, *Codice Magliabechiano (già Gaddi)*, XVII, 17, f. 91r; PIETRO C. MARANI, p. 45).

[17] MARTIN J. KEMP, GIUSEPPE PALLANTI, p. 30.

[18] FRANK ZÖLLNER, p. 117.

[19] The payment note is included in the register of accounts by the Languedil treasurer, entitled *Estat fait a maistre Jehan Groiler, conseiller du Roy notre sire, tresorier et receveur general de ses finances en ses pays et duché de Milan, conté d'Asti, et seigneur de Gennes [...]*, years 1517-18; Parigi, *Archives Nationales*, J910, fold. 6 (quoted by: PIETRO C. MARANI, p. 44).

[20] Massimo Giontella argues instead that Salaì, although charged by Leonardo, sold the paintings with the malicious purpose of not delivering the proceeds and than he even brought with him the original painting and a copy of *Gioconda* in Milan. The scholar believes that the original table is the one listed as «dona aretrata» in the hereditary inventory of 1525 (but in the *extensa* copy it bears the wording «dicto la Joconda»), while the other and different «picture told the Honda C°» would be a copy (identified by the letter C). This explanation, which admits the owning of the original *Gioconda* to Salaì, is based however on the weak hypothesis that the picture of the «certain Florentine woman, portayed from life at the behest of the late Magnificent Giuliano de' Medici» shown by Leonardo to the Cardinal of Aragon in Clos Lucé was the so-called *Belle Ferronière* and not the *Mona Lisa* (MASSIMO GIONTELLA, *Gioconda: "Allegoria della pittura". Assassinio e trafugamento*, Florence, 2017, pp. 43-46). However, the scholar does not explain how the passage of the original table from the heirs of Salaì to the king of France occurred, nor how the alleged portrait of Lucrezia Crivelli (*Belle Ferroniére*), hypothetically sold by Caprotti to the sovereign in the documented transaction for 1517- 1518, was perhaps already in attendance at the royal castle of Blois in October 1517: it would be proved by the description of Antonio de' Beatis written during his visit to the manor the following day (11 October 1517) the meeting with Leonardo, who noted that «There was also a painting in which a certain natural lady from Lombardy (a painting, where a Milanese woman is depicted from life) is painted in oil, very beautiful, but in my opinion not as beautiful as Signora Gualanda (Mrs. Isabella Gualanda)», which is commonly believed to be that of the *Belle Ferronière*.

[21] http://vinciana.blogspot.com/2016/03/il-testamento-di-leonardo-da-vinci-e.html

[22] Also Janice Shell believes that Salaì benefited only from a marginal part of Leonardo's testamentary donations because he gained the proceeds from the sale of the paintings to the king of France, which the Master himself had disposed and approved (JANICE SHELL, *Salaì and the Royal Collection at*

Louvre, in *L'opera grafica e la fortuna critica di Leonardo da Vinci*, Florence, 2006, pp. 40 and ff).

[23] ANTONIO FORCELLINO, pp. 310 and ff.

[24] The notarial document consists in a brief note, called *imbreviatura*, and a more formal draft, called *extensa*, in which appear, in their two identical lists of paintings, two female portraits, one of «dona aretrata» (i.e., 'portrayed lady') and the other called «Honda», both certainly copies, in my opinion, of the same *Gioconda*. For the publication and the comment of the inventory: JANICE SHELL, GRAZIOSO SIRONI, *Salaì and Leonardo's Legacy*, «The Burlington Magazine», vol. CXXXIII, 1055(1991), pp. 95-108; JANICE SHELL 2006, pp. 37-47; ARCHIVIO DI STATO DI MILANO, *Fondo notarile*, notaio Pietro Paolo Crevenna, filza 8136, 1 aprile 1525. See also: PIETRO C. MARANI, p. 45; MARTIN J. KEMP, GIUSEPPE PALLANTI, p. 109 and ff).

[25] About this topic: PIETRO C. MARANI, p. 34.

[26] Isaacson states the same doubts about the reliability of the estimate because of a deceptive reputation that circulated about them. (WALTER ISAACSON, p. 438).

[27] GIORGIO VASARI, JONATHAN FOSTER (ED.), vol. II, pp. 384 and ff.; GIORGIO VASARI, MAURIZIO MARINI (ED.), pp. 563.

[28] ARCHIVIO DI STATO DI MILANO, *Fondo notarile*, notaio Benedetto Casorati, filza 7704 (PIETRO C. MARANI, p. 45).

[29] Shell and Sironi read the note concerning this painting as «*non fornido*» (JANICE SHELL, GRAZIOSO SIRONI, *Salaì and Leonardo's Legacy* cit., pp. 96); since this adjective does not have a sense in the Italian notarial language of the time, I would like to suggest a different interpretation of the handwriting as, actually, «*non finito*» («unfinished»), which, in my opinion, one reads very clearly.

[30] JESTAZ BERNARD, *Francois Ier, Salaì et les tableaux de Léonardo*, «Revues de L'Art» CXXVI(1999), pp. 68-72; MARTIN J. KEMP, GIUSEPPE PALLANTI, pp. 113 and ff.

[31] «*[…] ne' ritratti fatti da gl'eccellenti pittori […] si veggono quelli di mano di Leonardo, ornati a guisa di primavera, come il ritratto della Gioconda e di Monna Lisa, ne' quali ha espresso tra l'altre parti meravigliosamente la bocca in atto di ridere*». (GIOVANNI PAOLO LOMAZZO, *Trattato dell'arte della pittura, scoltura et architettura*, Milan, Pietro Tini, 1584, p. 434).

[32] PIETRO C. MARANI, p. 46; MARTIN J. KEMP, GIUSEPPE PALLANTI, p. 118.

[33] «*Il che* [l'eccellenza e la perfezione, rev. by Author] *chi desidera di veder nella pittura, miri l'opere finite, (benché siano poche) di Leonardo da Vinci, come la Leda ignuda, et il ritratto di Monna Lisa napoletana che sono nella fontana di Belao in Francia, e conoscerà quanto l'arte superi, et quanto sia più potente in tirare à se gli occhi de gli intendenti, che l'istessa natura.*» (GIOVANNI PAOLO LOMAZZO, *Idea del Tempio*

della Pittura nella quale egli discorre dell'origine e fondamento delle cose contenute nel suo trattato dell'arte della pittura, Milan, Paolo Gottardo Ponto, 1590, pp. 6 and ff).

[34] CARLO VECCE, *Leonardo*, Rome, Salerno Editrice, 1998, pp. 332-336.

[35] On the right reasons that would deny the identification of the lady of the Louvre's poplar panel as Isabella Gualanda: FRANK ZÖLLNER, pp. 130-1, note 9. Antonio de' Beatis in his diary drafted during the journey to France of the cardinal of Aragon, notes that in the castle of Blois «there was also a painting where is painted in oil a very beautiful lady of Lombardy, but to my judgment not so much as Mrs. Gualanda» painted by Leonardo, proving to have met himself Isabella Gualanda, and to assume her as a comparison of beauty. It is hard to believe that, observing a different portrait and, invoking for it the name of the Neapolitan lady, he intended to refer to the *Mona Lisa* he had seen the day before. It is believed that the painting seen by de' Beatis in the castle of Blois was perhaps the portrait of Lucrezia Crivelli, known as the *Belle ferronière* (BIBLIOTECA NAZIONALE VITTORIO EMANUELE II DI NAPOLI, *Manoscritto X*, F 28, 11 ottobre 1517); MARANI PIETRO C., p. 44.

[36] BIBLIOTECA BARBERINI, *Manoscritto Barberini* LX, n. 64, ff. 192v-194v; MARTIN J. KEMP, GIUSEPPE PALLANTI, p. 120.

[37] WALTER ISAACSON, p. 414.

[38] For a brief but exhaustive description of the radiographic and reflectography analyzes on the *Gioconda*: MARTIN J. KEMP, GIUSEPPE PALLANTI, pp. 197-209.

[39] «*Mais le cinquiéme en nombre, et le premier en estime, comme une merveille de la Peinture, est le portait d'une vertueuse Dame Italienne, et non pas d'une Cortisan (comme quelques-uns croyent) nommée Mona Lissa, vulgairement appellée Ioconde, laquelle estoit femme d'un Gentilhomme Ferrarois appellé François Iocondo, amy intime du dit Leonard, lequel l'ayant prié de luy permettre de faire ce portait de sa femme, il luy accorda. Le grand Roi François achepta ce Tableau douze mille francs.*» (PIERRE DAN, *Le trésor des merveilles de la Maison Royale de Fontainebleau*, Paris, chez Sebastien Cromoisy, 1642, pp. 135-136).

[40] WALTER ISAACSON, pp. 407 and ff.

[41] ANDRÉ FÉLIBIEN, *Entretiens sue les vies et les ouvrages des plus excellent peintres anciens et modernes*, Paris, Trevous, 1666, vol. IV., p. 166.

[42] ABBÉ GUILBERT, *Description historique des chateau, bourg et forest de Fontainebleau*, chez André Cailleau, Paris, 1731, I vol., pp. 153-159; FRANK ZÖLLNER, p. 116.

[43] PIETRO C. MARANI, p. 10.

[44] LEONARDO DA VINCI, JOHN FRANCIS RIGAUD (ED.), *A treatise on painting*, London, J. Taylor, 1802 (orig. ed. 1721), p. 134.

[45] WALTER PATER, DONALD HILL (ED.), *The Renaissance. Studies in art and poetry*, London, 1980, (orig. ed. 1893), pp. 98-99.

[46] ALBERTO ANGELA, p. 199; CARLO STARNAZZI, CESARE MAFUCCI, *Il paesaggio della Gioconda*, Arezzo, 1993; http://www.artsblog.it/post/21527/la-gioconda-e-i-dubbi-sullo-sfondo-del-ritratto-piu-famoso-al-mondo

[47] «It is certainly not a real landscape, as have never been al the landscapes painted by Leonardo, but the combinatory memory of really seen places and places only dreamed of, from the Lombard mountains of Grigna to the visions of primordial peaks carved from the water when the world was created» (CARLO VECCE 1998, *Leonardo* cit., p. 325; Transl. by Author).

[48] GALLERIA DEGLI UFFIZI, *Gabinetto dei Disegni e delle Stampe*, n. 8p.

[49] CARLO PEDRETTI, *«Gioconda in volo»*, in PIETRO C. MARANI, p. 6.

[50] LEONARDO DA VINCI, *Codex Leicester (or Hammer)* f. 9r (Trasl. by Author).

[51] MARTIN J. KEMP, *Leonardo. Nella mente del genio*, Turin, 2006, p. 97.

[52] KENNETH CLARK, in *Leonardo da Vinci. Studi di Natura dalla Biblioteca reale nel Castello di Windsor*, Florence, 1982, p. 18.

[53] KENNETH CLARK, *Leonardo da Vinci Storia della sua evoluzione artistica*, Milan, 1983 (ed orig. 1939), pp. 137 and ff.

[54] For a summary of the various critical proposals: WEBSTER SMITH, *Observation on the Monna Lisa landscape*, «The art bulletin» LXVII(1985), n. 2, pp. 103 and ff.

[55] KEMP MARTIN 2006, pp. 86-107.

[56] LEONARDO DA VINCI, *Manuscript A*, f. 55v.

[57] KEMP MARTIN 2006, p. 87.

[58] LEONARDO DA VINCI, *Codex Atlanticus*, f. 327v; LEONARDO DA VINCI, JEAN PAUL RICHTER (ED.), *The notebooks of Leonardo da Vinci (complete)*, Alexandria USA, Library of Alexandria, ISBN 9781465514141 (orig. ed. 1888), vol. I, p. 22.

[59] «The earth is all hollow in every part, and is full of veins and caves, and yet the waters that went from the sea come and go troughout the earth, and arise in and out, as the veins carry them around; just as the blood of man spreads through his veins, so that it bedews the whole body from top to bottom» (BRUNETTO LATINI, *Li Livres dou Tresor*, I, II, cap. 36; MARTIN J. KEMP, *Lezioni dell'occhio. Leonardo da Vinci discepolo dell'esperienza*, Milan, 2004, p. 349; Transl. by Author).

[60] Webster Smith, in declared antithesis to Kemp's theses, proposes to take the analogy between man and the cosmos that Leonardo expresses in *Manuscript A* and in the *Codex Leicester* in the metaphorical sense attributed to it in the book by Ristoro of Arezzo, or rather as a simple literary exercise with no other value: «By now, ca 1508-10, he can speak metaphorically, as for the most part he did earlier, of the human body itself as the microcosm» (WEBSTER SMITH, p. 188).

[61] LEONARDO DA VINCI, *Codex Leicester*, f. 34r; LEONARDO DA VINCI,

McCurdy Edward (Ed.), *Leonardo da Vinci's note-books*, New York, Empire State Book Company, 1923, p. 131.
[62] Leonardo da Vinci, *Codex Leicester*, f. 35v.
[63] *Ivi*, f. 33v (Trans. by Author).
[64] Martin Kemp well explains the sense of this cosmic sympathy: «the supreme design or underlying analogy is the image of the universe as a complex living organism whose properties are reflected in miniature in all its parts. The body of the earth and the body of man are part of a great interrelated system of dynamics and statics, heat and light, growing and decline, life and death» (Martin J. Kemp 2004, p. 182; Trans. by Author).
[65] Marco Rosci, *Leonardo*, Milan, 1979, p. 151.
[66] Jane Roberts, in *Il codice Leicester di Leonardo da Vinci. Le acque, la terra, l'universo*, Florence, Giunti-Barbera, 1982, p. 15.
[67] This thesis is explained in the manuscripts *Manuscript C*, *Manuscript A*, *Arundel Manuscripts*, and even in the *Codex Leicester* (Webster Smith, p. 190).
[68] Martin J. Kemp 2004, p. XIII; see also: Jane Roberts, p. 19.
[69] Leonardo da Vinci, *Manuscript A*, f. 93r (Trans. by Author).
[70] Webster Smith, p. 198.
[71] Donald Sassoon, pp. 113, 163.
[72] https://conservation-science.unibo.it/article/download/6168/5937.
[73] Alberto Angela, p. 97; https://restaurionline.wordpress.com/2017/01/30/le-copie-ovvero-le-versioni-de-la-gioconda-a-confronto-valutazione-storico-artistica-e-diagnostico-analitica-3-la-gioconda-del-prado-3-1-anamnesi-storica/
[74] Martin Giuseppe Kemp, Pallanti, pp. 209-12; Costantino D'Orazio, p. 169.
[75] Pietro Marani recalls that Leonardo advised using walnut wood in his early *Manuscript A* (1490-92) (Pietro C. Marani, p. 11).
[76] About the LAM method and the results gained by Pascal Cotte: Martin J. Kemp, Giuseppe Pallanti, pp. 213-223.
[77] Alberto Angela, p. 100; Salvatore Lorusso, Andrea Natali, *Mona Lisa: a comparative evaluation from different versions and their copies*, in «Conservation science in cultural Heritage», 15(2015), pp. 68-82.
[78] Salvatore Lorusso, Andrea Natali, p. 72.
[79] *Ibi*, p. 69.
[80] «But, though his art was requested by many, due to his unstable mind and a natural habit to be fed up soon of his started works, after having gave up some paintings already undertaken, he completed very few works» (Paolo Giovio, *Dialogus de viris litteris illustribus, cui in calce sunt additæ Vincii, Michaelis Angeli, Raphaelis Urbinatis Vitæ*, in Girolamo Tiraboschi, *Storia della letteratura italiana*, Tipografia Molinari, Venezia, 1824, tomo VII, parte VII;

Trans. by Author).
[81] ALBERTO ANGELA, p. 99; SALVATORE LORUSSO, CHIARA MATTEUCCI, ANDREA NATALI, SALVATORE ANDREA APICELLA, FLAVIA FIORILLO, *Diagnostic-analytical study of the painting "Gioconda with columns"*, in «Conservation science in cultural Heritage», 13(2013), pp. 75-102.
[82] SALVATORE LORUSSO, ANDREA NATALI, pp. 65-68.
[83] LEONARDO DA VINCI, ANGELO BORZELLI (ED.), p. 76; LEONARDO DA VINCI, MCCURDY EDWARD (ED.), p. 12 (Trans. by Author).
[84] LEONARDO DA VINCI, ANGELO BORZELLI (ED.), p. 148 (Trans. by Author).
[85] LEONARDO DA VINCI, *Manuscript A*, f. 107r; MARTIN J. KEMP 2006, p. 81; LEONARDO DA VINCI, MCCURDY EDWARD (ED.), p. 190-91.
[86] According to ancient sources, expecially Xenophon (*Memorabili*), Cicero (*De inventione*) and Pliny (*Naturalis historia*), the famous painter Zeusi, commissioned to depict a figure of Helen for the Kroton temple of Hera Lacinia, chose five young and beatiful girls from whom he selected the most beautiful features to compose an ideal figure of a woman. This method, by selection or 'collection', was always taken as the most direct, alternative to the process of amendment of defects, to gain the so-called 'ideal beauty' and therefore appreciated in classicist aesthetics, up to Neoclassicism, as, for example, stated by Francesco Milizia (FRANCESCO MILIZIA, *Dizionario delle belle arti del disegno estratto in gran parte dalla enciclopedia metodica*, Remondini Tip. ed Editore, Bassano, MDCCCXXII, vol. II, p. 8).
[87] MARTIN J. KEMP 2006, p. 81.
[88] LEONARDO DA VINCI, ANGELO BORZELLI (ED.), pp. 59 and ff (Trans. by Author).
[89] LEONARDO DA VINCI, MCCURDY EDWARD (ED.), p. 163.

NOTES TO CHAPTER TWO

[1] ALBERTO ANGELA, p. 226; COSTANTINO D'ORAZIO, p. 163; PIETRO C. MARANI, p. 12.
[2] Giovanni Villa believes, wrongly according to my opinion, that the portrait is «incomplete in some parts of the composition: from the balaustrade to some pieces of the landscape on the right from which glimpses the reddish-brown primer (*imprimitura*)» (GIOVANNI C.F. VILLA, *Leonardo pittore l'opera completa*, Milan, 2011, p. 182; Transl. by Author).

NOTES

³ This passage from the *Arundel Code* (LEONARDO DA VINCI, *Codex Arundel*, 155r; LEONARDO DA VINCI, MCCURDY EDWARD (ED.), p. 135) seems to came from a literary or poetic description:

> «Nor does the tempestuous sea make so loud a roaring when the northern blast beats it back in foaming waves between Scylla and Charybdis, nor Stromboli not Mount Etna when the pent-up, sulphurous fires, bursting open and rending asunder the mighty mountain by their force, are hurling through the air rocks and earth mingled together in the issuing belching flames. Nor when Etna's burning caverns vomit forth and give out again the uncontrollable element, and thrust it back to its own region in fury, driving before it whatever obstacle withstands its impetuous rage».

⁴ LEONARDO DA VINCI, *Codex Leicester*, f. 34r; LEONARDO DA VINCI, MCCURDY EDWARD (ED.), p. 131; MARTIN J. KEMP, GIUSEPPE PALLANTI, p. 183.
⁵ LEONARDO DA VINCI, *Manuscript A*, f. 98v; LEONARDO DA VINCI, JEAN PAUL RICHTER (ED.), p. 529.
⁶ LEONARDO DA VINCI, *Codex Atlanticus*, 520r.
⁷ «So I mean about these mathematical things, that those who only are studying the authors and not the works of nature, are nephews, not son of nature, teacher of good authors. I catched a great foolishness in those who blame those who are learning from nature, leaving the authors, disciples of nature!» (LEONARDO DA VINCI, *Codex Atlanticus*, 387r (Trans. by Author). «Though I may not, like them, be able to quote other authors, I shall rely on that which is much grater and more worty: on experience, the mistress of their Masters» (LEONARDO DA VINCI, JEAN PAUL RICHTER (ED.), p. 22).
⁸ FRANCESCO CARDONE, *Aria Acqua Terra e Fuoco. Storia della chimica dagli albori a Lavoisier*, Reggio Calabria, 1999, p. 49.
⁹ LEONARDO FIORAVANTI, *Della fisica dell'eccell.te dottor et cavaliere M. Leonardo Fiorauanti Bolognese, per gli Heredi di Melchior Serra, Venezia, 1582*, vol. I, p. 11.
¹⁰ LEONARDO DA VINCI, *Codex Atlanticus*, f.1067r; LEONARDO DA VINCI, JEAN PAUL RICHTER (ED.), p. 582.
¹¹ LEONARDO DA VINCI, *Codex Atlanticus*, f. 340r (Trans. by Author); CESARE VASOLI (ED.), PAOLO COSTANTINO PISSAVINO (ED.), *Le filosofie del Rinascimento*, Milan, 2002, p. 445.
¹² LEONARDO DA VINCI, *Codice Forster III*, f. 2r; MCCURDY EDWARD (ED.), p. 261.
¹³ ANDREA BERNARDONI, *Gli elementi e la costituzione del mondo in Leonardo da Vinci*, in *Atti del XIII Convegno Nazionale di Storia e Fondamenti della Chimica*, Rome, Accademia Nazionale delle Scienze detta dei XL, 2009, p. 82.
¹⁴ LEONARDO DA VINCI, *Codex Atlanticus*, f. 214v (Trans. by Author). This *folio* of *Codex Atlanticus* has been dated by Carlo Pedretti between 1505 and 1506 (BERNARDONI ANDREA, *Elementi, sostanze naturali, atomi: osservazioni*

sulla struttura della materia nel Codice Arundel *di Leonardo*, in ANDREA BERNARDONI (ED.), GIUSEPPE FORNARI (ED.), *Il codice Arundel di Leonardo: ricerche e prospettive*, Poggio a Caiano, 2011, p. 79).

[15] LEONARDO DA VINCI, *Codex Arundel*, f. 189r (Transl. by Author); ANDREA BERNARDONI 2009, p. 82.

[16] LEONARDO DA VINCI, *Royal Collection at Windsor Castle*, f. 153r (19060r); from MARTIN J. KEMP 2006, p. 186 (Trans. by Author).

[17] ANDREA BERNARDONI 2009, p. 84.

[18] «The simple earth can not get gravity. The simple fire does not acquire levity» (LEONARDO DA VINCI, *Codex Atlanticus*, f. 214v; Trans. by Author).

[19] Bernardoni states in this regard: «In other cases, to explain the generation of winds or the pressure that occurs in the bombards, he attributes to all elements, including air and fire, the ability to acquire weight or force through condensation. [*Manuscript F*, 16, f. 69v; 12, f. 21r, f. 100v]. However, despite these observations openly disagree with the traditional theory of the four elements, Leonardo fails to organize his observations in order to produce a theory of motion alternative to Aristotle» (ANDREA BERNARDONI 2009, p. 87; Trans. by Author).

[20] LEONARDO DA VINCI, *Manuscript F*, f. 69v (Trans. by Author).

[21] About this issue: ANDREA BERNARDONI 2011, pp. 84-88.

[22] *Manuscript F* contains two contradictory statements about the Earth element: at first, is perceived by Leonardo in its corpuscular form as a tetrahedron, more massive than the cube (f 728v), but in f. 61r refers to its flexibility («*De moto locale, de fressibile arido, cioè polvere e simili*») perhaps with respect to his remarks about the properties of metals. Andrea Bernardoni suggests that Leonardo minded finally that all the corpuscles of the four Elements were be featured by the same spherical shape (ANDREA BERNARDONI 2011, p. 91).

[23] LEONARDO DA VINCI, *Manuscript F*, f. 728v; da ANDREA BERNARDONI 2009, p. 87.

[24] About this issue: ANDREA BERNARDONI 2011, p. 102.

[25] LEONARDO DA VINCI, *Codex Atlanticus*, f. 241v, from: ANDREA BERNARDONI 2011, p. 88 (Trasl. by Author).

[26] MARTIN KEMP 2004, p. 133. CARLO VECCE, *La biblioteca perduta I libri di Leonardo*, Rome, 2017, p. 67.

[27] About the relief and disclosure of *Corpus Hermeticum* during the Renaissance: GIUSEPPE MARINELLI, *Misteri alchemici nella pittura del Rinascimento italiano*, ISBN 9781549809774, 2017, pp. 28 and ff.

[28] CARLO VECCE 2017, pp. 72, 182, note 32).

[29] LEONARDO DA VINCI, *Manuscript A*, f. 55v; LEONARDO DA VINCI, MCCURDY EDWARD (ED.), p. 93 and ff.

[30] LEONARDO DA VINCI, *Royal Collection at Windsor Castle*, f. 19037v;

NOTES

MARTIN KEMP 2004, pp. 12 and ff.

[31] LEONARDO DA VINCI, *Codex Arundel*, f. 156v; LEONARDO DA VINCI, PETER RUSSEL (ED.), *Delphi complete Works of Leonardo da Vinci*, Hustings, 2014, p. 1432.

[32] LEONARDO DA VINCI, *Manuscripts of Anatomy*, f. 35r; LEONARDO DA VINCI, MCCURDY EDWARD (ED.), p. 74. Also: MARTIN KEMP, *The marvellous works of Nature and Man*, London, 1981, p. 127.

[33] ANDREA BERNARDONI 2011, pp. 93.

[34] Even Kenneth Clark is convinced of the absolute femininity of the portrayed woman: «Femminility is an essential element in this disquieting image. [...] the point of the *Mona Lisa* is precisely that she is a woman» (KENNETH CLARK, *Mona Lisa*, in «The Burlington Magazine», n. 840, CXV(1973), p. 179.

[35] Being distinct from the common elements, the alchemical Sulfur and Mercury are pointed out in these essay with the initial capital letter.

[36] On the symbolism of the *Rebis*: GIUSEPPE MARINELLI, pp. 140, 405.

[37] The drawing (Oxford, *Governing Body*, Christ Church, Inv. JBS 17v), according to Nathan and Zöllner would represent an allegory of envy and would date from around 1490-94 (JOHANNES NATHAN, FRANK ZÖLLNER, *Leonardo da Vinci 1452-1519 Drawings*, Cologne, 2017, p. 443); it ought to be taken in account jointly with two other ones that show as many allegories of the same moral subject included in two sheets kept at Oxford. According to other scholars this image expresses an unsolved dualism: Pleasure against Pain or Virtue against Envy (EUGÈNE MÜNZ, *Leonardo da Vinci*, New York, 2006 (ed orig. 1898), vol II, p. 14; CHARLES NICHOLL, *Leonardo da Vinci: The flights of the Mind*, London, 2005, p. nn).

[38] LEONARDO DA VINCI, PETER RUSSEL (ED.), p. 781.

[39] LEONARDO DA VINCI, JOHN FRANCIS RIGAUD (ED.), p. 89; LEONARDO DA VINCI, ANGELO BORZELLI (ED.), p. 92.

[40] LEONARDO DA VINCI, JOHN FRANCIS RIGAUD (ED.), p. 117; LEONARDO DA VINCI, ANGELO BORZELLI (ED.), p. 89.

[41] LEONARDO DA VINCI, JOHN FRANCIS RIGAUD (ED.), p. 154; LEONARDO DA VINCI, ANGELO BORZELLI (ED.), p. 85.

[42] LEONARDO DA VINCI, JOHN FRANCIS RIGAUD (ED.), pp. 151-2, 162; LEONARDO DA VINCI, ANGELO BORZELLI (ED.), pp. 86, 88.

[43] LEONARDO DA VINCI, JOHN FRANCIS RIGAUD (ED.), p. 130; LEONARDO DA VINCI, ANGELO BORZELLI (ED.), p. 92.

[44] LEONARDO DA VINCI, MCCURDY EDWARD (ED.), p. 159-160; LEONARDO DA VINCI, ANGELO BORZELLI (ED.), p. 27.

[45] LADISLAO RETI, *Le arti chimiche di Leonardo da Vinci*, «La chimica e l'industria», XXXIV(1952), pp. 5-36; GIACOMO MARIA PRATI, *Leonardo e l'alchimia*, http://wsimag.com/ it/arte/13338-leonardo-e-lalchimia; CESARE

VASOLI, *Note su Leonardo e l'alchimia*, in ENRICO BELLONE (ED.), PAOLO ROSSI (ED.), *Leonardo e l'età della Ragione*, Milan, 1982, pp. 69-77.

[46] GIANCARLO SIGNORE, *Alchimia, Evoluzione ed involuzione della Grande Arte*, Milan, 2017, p. nn.

[47] On the behavior reserved by the civil and religious powers towards the alchemists during the centuries: GIUSEPPE MARINELLI, pp. 62 and ff., notes 10, 11.

[48] About Medieval Latin and Renaissance alchemy features and the so-called *quæstio de alchimia*: GIUSEPPE MARINELLI, pp. 4-35.

[49] On the Leonardo's fame along his life: KENNETH CLARK 1983, pp. 19 and ff. For the originality of his writing: ANGELO PARATICO, pp. 248-258.

[50] SERGE BRAMLEY, pp. 7 and ff.

[51] GIORGIO VASARI, JONATHAN FOSTER (ED.), vol. II, pp. 366, 370; GIORGIO VASARI, MAURIZIO MARINI (ED.), pp. 557, 559.

[52] BENVENUTO CELLINI, *Discorso dell'architettura*; in *Le opere di Benvenuto Cellini*, Florence, 1843, p. 531 (Trans. by Author); SERGE BRAMLEY, p. 9 and ff.

[53] ANDRÉ CHASTEL, *Leonardo o la scienza della pittura*, Milan, 2008, p. 16.

[54] LEONARDO DA VINCI, ANGELO BORZELLI (ED.), pp. 205 and ff. (Trasl. By Author).

[55] LEONARDO DA VINCI, PETER RUSSEL (ED.), p. 390; LEONARDO DA VINCI, MARINONI AUGUSTO (ED.), *Scritti letterari di Leonardo da Vinci*, Milan, 1974, p. 2.

[56] LEONARDO DA VINCI, *Manuscript E*, 55r (Trans. by Author).

[57] LEONARDO DA VINCI, PETER RUSSEL (ED.), p. 1159; LEONARDO DA VINCI, *Codex Forster II*, f. 90v; LADISLAO RETI, p. 14.

[58] LEONARDO DA VINCI, MCCURDY EDWARD (ED.), p. 68; LEONARDO DA VINCI, *Anatomical manuscript B*, f. 49v; AUGUSTO MARINONI (ED.), pp. 96 and ff.

[59] LEONARDO DA VINCI, MCCURDY EDWARD (ED.), p. 81-82; LEONARDO DA VINCI, *Anatomical manuscript B*, f. 50v; LADISLAO RETI, p. 15.

[60] LEONARDO DA VINCI, MCCURDY EDWARD (ED.), p. 82; LEONARDO DA VINCI, *Anatomical manuscript B*, f. 50v.

[61] AVICENNA, *De congelatione et conglutinatione lapidum (Kitab al-Shifa)*, in: CHIARA CRISCIANI, MICHELA PEREIRA, *L'arte del sole e della luna Alchimia e filosofia nel medioevo*, Spoleto, 1996, p. 136 (Transl. by Author).

[62] About the question of the 'sole mercury': CHIARA CRISCIANI, *L'alchimia dal Medioevo al Rinascimento: scientia o ars?*, in *Il Rinascimento italiano e l'Europa*, Treviso, 2008, vol. V, p. 121; ROBERT HALLEAUX, *L'alchimia nel Medioevo latino e greco*, in *Storia della Scienza*, Rome, 2001, p. 547.

[63] LEONARDO DA VINCI, PETER RUSSEL (ED.), p. 1160; LEONARDO DA VINCI, *Codex Atlanticus*, f. 207v. See also: ANDREA BERNARDONI 2011, pp. 94 and ff.

[64] ALBERTO ANGELA, p. 132; GIACOMO MARIA PRATI, *Leonardo e l'alchimia*, http://wsimag.com/ it/arte/13338-leonardo-e-lalchimia; GIANCARLO SIGNORE, p. nn.
[65] GIUSEPPE MARINELLI, p. 36; GIACOMO MARIA PRATI, *Leonardo e l'alchimia*, http://wsimag.com/it/arte/13338-leonardo-e-lalchimia.
[66] GIORGIO VASARI, JONATHAN FOSTER (ED.), vol. V, p. 68; GIORGIO VASARI, MAURIZIO MARINI (ED.), p. 1126.
[67] SERGE BRAMLEY, p. 110.
[68] *Ibi*, p. 306.
[69] LADISLAO RETI, p. 15.
[70] Among the people that Leonardo saw within the Sforza court, it is certainly worth remembering Ambrogio Varese da Rosate, the Moro's official astrologer and archiater; (GEROLAMO D'ADDA, *Leonardo da Vinci e la sua libreria. Note di un bibliofilo*, Milan, tipi di G. Bernardoni, 1883, pp. 36 and ff, note 1); Malaguzzi Valeri suggests even the acquaintance of such Maestro Leone, astrologer, alchemist, who, however, fell into disgrace with Ludovico Sforza (LADISLAO RETI, p. 15).
[71] For complete informations on Leonardo's library: GEROLAMO D'ADDA, pp. 5-53; ANNA MARIA BRIZIO (ED.), *Scritti scelti di Leonardo da Vinci*, Turin, 1968^2, pp. 655-675; CARLO VECCE 2017.
[72] During his stay in Rome, Leonardo had as assistants two German craftsmen skilled in mirrors, such as Giorgio and Maestro Giovanni degli Specchi, with whom he wished build a gigantic parabolic mirror. With them the relationship soon became harsh, to the point that he suspected that Giorgio wanted to steal his knowledges; thus, he began to use the alchemy cryptic paraphrase to preserve the confidentiality of his researches. Maestro Giorgio, on the other hand, facing these sentences, accused Leonardo of magic (SERGE BRAMLEY, p. 341).
[73] LEONARDO DA VINCI, *Anatomical manuscript B*, f. 50v.
[74] LADISLAO RETI, pp. 8-11.

NOTES TO CHAPTER THREE

[1] As Argan *Mona Lisa* is rightly «the image of *nature naturans*, which is endlessly doing and undoing itself, of the cyclic passing of matter from the solid state to the liquid, to the atmospheric: the figure is no longer the opposite of nature, but the final term of his continuous evolution » (GIULIO

Notes

Carlo Argan, *Storia dell'arte italiana*, Florence, 2000², vol. III, p. 264; Transl. by Author).

[2] Also for Antonio Forcellino she is a «elusive woman who symbolizes a new divinity, a natural power that sums up in herself the power of spirit and nature, and seems determined to maintain the secret of that endless transformation»; but the author, as my opinion, does not manage to decipher the dynamics of the Elements that constitute the subject of the geological mutation depicted in the landscape, nor to identify the woman as a personification of Nature itself, as in the present essay (Antonio Forcellino, pp. 299 and ff; Transl. by Author).

[3] Leonardo da Vinci, Peter Russel (Ed.), p. 952; Leonardo da Vinci, *Code Forster III*, f. 20v.

[4] Leonardo da Vinci, McCurdy Edward (Ed.), p. 271; Leonardo da Vinci, *Codex Atlanticus*, f. 393r.

BIBLIOGRAPHY

Given the large number of publishings and manuscripts consulted, the following is a summary bibliographical selection only of those quoted in the text notes. If not otherwise specified, the quotes taken from Leonardo's codes follow the numbering of the *folio* and the transcription of the text as they are provided by the elaborations of the website www.leonardodigitale.com.

Atti del XIII Convegno Nazionale di Storia e Fondamenti della Chimica, Rome, 2009.

Il Rinascimento italiano e l'Europa, Treviso, 2008.

Le opere di Benvenuto Cellini, Florence, 1843.

Leonardo da Vinci. Studi di Natura dalla Biblioteca reale nel Castello di Windsor, Giunti Barbèra Editore, Florence, 1982.

L'opera grafica e la fortuna critica di Leonardo da Vinci, Florence, 2006.

Storia della Scienza, Rome, 2001.

ANGELA ALBERTO, *Gli occhi della Gioconda Il genio di Leonardo raccontato da Monna Lisa*, 2016, p. 290.

ARGAN GIULIO CARLO, *Storia dell'arte italiana*, Florence, 2000².

Bibliography

BAMBACH CARMEN C., *Leonardo da Vinci master draftsman*, New Haven-London, 2003.

BELLONE ENRICO (ED.), ROSSI PAOLO (ED.), *Leonardo e l'età della Ragione*, Milan, 1982.

BERNARDONI ANDREA (ED.), FORNARI GIUSEPPE (ED.), *Il Codex Arundel di Leonardo: ricerche e prospettive*, Poggio a Caiano, 2011.

BRAMLEY SERGE, *Leonardo da Vinci artista, scienziato, filosofo*, Milan, 2017^2.

BRIZIO ANNA MARIA (ED.), *Scritti scelti di Leonardo da Vinci*, Turin, 1968^2.

CARDONE FRANCESCO, *Aria Acqua Terra e Fuoco. Storia della chimica dagli albori a Lavoisier*, Reggio Calabria, 1999.

CHASTEL ANDRÉ, *Leonardo o la scienza della pittura*, Milan, 2008.

CLARK KENNETH, *Leonardo da Vinci Storia della sua evoluzione artistica*, Milan, 1983 (orig. ed. 1939).

CRISCIANI CHIARA, PEREIRA MICHELA, *L'arte del sole e della luna Alchimia e filosofia nel medioevo*, Spoleto, 1996.

D'ADDA GEROLAMO, *Leonardo da Vinci e la sua libreria. Note di un bibliofilo*, Milan, 1883.

D'ORAZIO COSTANTINO, *Leonardo segreto*, Milan, 2014, p. 160.

DAN PIERRE, *Le trésor des merveilles de la Maison Royale de Fontainebleau*, chez Sebastien Cromoisy, Paris, 1642.

DE SANTI ABATI AGOSTINO, *I segreti codici della Gioconda*, Montevarchi, 2015.

FÉLIBIEN ANDRÉ, *Entretiens sue les vies et les ouvrages des plus excellent peintres anciens et modernes*, Paris, 1666.

FIORAVANTI LEONARDO, *Della fisica dell'eccell.te dottor et cavaliere M. Leonardo Fiorauanti Bolognese*, per gli Heredi di Melchior Serra, Venice, 1582.

FORCELLINO ANTONIO, *Leonardo. Genio senza pace*, Bari-Rome, 2016.

FREUD SIGMUND, *Eine Kindheitserinnerung des Leonardo da Vinci*, Leipzig-Wien, 1910.

GELB MICHAEL J., *Pensare come Leonardo. I sette princìpi del genio*, Milan 2010[3].

GIONTELLA MASSIMO, *Gioconda: "Allegoria della pittura". Assassinio e trafugamento*, Florence, 2017.

GUILBERT ABBÉ, *Description historique des chateau, bourg et forest de Fontainebleau*, chez André Cailleau, Paris, 1731.

ISAACSON WALTER, *Leonardo da Vinci*, Milan, 2017.

JESTAZ BERNARD, *Francois Ier, Salaì et les tableaux de Léonardo*, «Revues de L'Art» CXXVI(1999).

MARTIN KEMP, *The marvellous works of Nature and Man*, London, 1981.

KEMP MARTIN, *Lezioni dell'occhio. Leonardo da Vinci discepolo dell'esperienza*, Milan, 2004.

KEMP MARTIN, PALLANTI GIUSEPPE, *Mona Lisa The people and the painting*, Oxford, 2017.

LATINI BRUNETTO, *Li Livres dou Tresor*, 1260-1266.

LEONARDO DA VINCI, *Codex Arundel.*

LEONARDO DA VINCI, *Codex Atlantico.*

LEONARDO DA VINCI, *Codex Forster II.*

Leonardo da Vinci, *Codex Forster III*.

Leonardo da Vinci, *Codex Hammer*.

Leonardo da Vinci, *Manuscript A*.

Leonardo da Vinci, *Manuscript E*.

Leonardo da Vinci, *Manuscript F*.

Leonardo da Vinci, *Anatomical manuscipt B*.

Leonardo da Vinci, *Royal Collection at Windsor Castle*.

Leonardo da Vinci, Borzelli Angelo (Ed.), *Trattato della pittura*, Lanciano, 1947.

Leonardo da Vinci, McCurdy Edward (Ed.), *Leonardo da Vinci's note-books*, New York, 1923.

Leonardo da Vinci, Rigaud John Francis (Ed.), *A treatise on painting*, London, 1802 (orig. ed. 1721).

Leonardo da Vinci, Russel Peter (Ed.), *Delphi complete Works of Leonardo da Vinci*, Hustings, 2014.

Lomazzo Giovanni Paolo, *Idea del Tempio della Pittura nella quale egli discorre dell'origine e fondamento delle cose contenute nel suo trattato dell'arte della pittura*, Paolo Gottardo Ponto, Milan, 1590.

Lomazzo Giovanni Paolo, *Trattato dell'arte della pittura, scoltura et architettura*, Pietro Tini, Milan, 1584.

Lorusso Salvatore, Matteucci Chiara, Natali Andrea, Apicella Salvatore Andrea, Fiorillo Flavia, *Diagnostic-analytical study of the painting "Gioconda with columns"*, in «Conservation science in cultural Heritage», 13(2013).

Lorusso Salvatore, Natali Andrea, *Mona Lisa: a comparative evaluation from different versions and their copies*, in «Conservation science in cultural Heritage», 15(2015).

MARANI PIETRO C., *Leonardo la Gioconda*, «Art e dossier», 189(2003).

MARINELLI GIUSEPPE, *Misteri alchemici nella pittura del Rinascimento italiano*, ISBN 9781549809774, 2017.

MARINONI AUGUSTO (ED.), *Scritti letterari di Leonardo da Vinci*, Milan, 1974.

MILIZIA FRANCESCO, *Dizionario delle belle arti del disegno estratto in gran parte dalla enciclopedia metodica*, Bassano, MDCCCXXII.

MÜNZ EUGÈNE, *Leonardo da Vinci*, New York, 2006 (ed orig. 1898).

NATHAN JOHANNES, ZÖLLNER FRANK, *Leonardo da Vinci 1452-1519 Disegni*, Colonia, 2017.

NICHOLL CHARLES, *Leonardo da Vinci: The flights of the Mind*, London, 2005.

PALLANTI GIUSEPPE, *Monna Lisa. Mulier ingenua*, Edizioni Polistampa, Florence, 2004; ID., *La vera identità della Gioconda*, Milan, 2006.

PARATICO ANGELO, *Leonardo da Vinci Un intellettuale cinese nel Rinascimento italiano*, Verona, 2017.

WALTER PATER, DONALD HILL (ED.), *The Renaissance. Studies in art and poetry*, London, 1980, (ed. 1893).

PEDRETTI CARLO, *Leonardo & Io*, Milan, 2008.

PRATI GIACOMO MARIA, *Leonardo e l'alchimia*, http://wsimag.com/ it/arte/13338-leonardo-e-lalchimia

RETI LADISLAO, *Le arti chimiche di Leonardo da Vinci*, «La chimica e l'industria», XXXIV(1952).

RICHTER JEAN PAUL (ED.), *The notebooks of Leonardo da Vinci (complete)*, Alexandria USA, ISBN 9781465514141, (orig. ed.

1888).

ROBERTS JANE, in *Il Codex Hammer di Leonardo da Vinci. Le acque, la terra, l'universo*, Florence, 1982.

ROSCI MARCO, *Leonardo*, Mondadori, Milan, 1979.

SASSOON DONALD, *Il mistero della Gioconda. La storia di un dipinto attraverso le immagini*, Milan, 2006.

SHELL JANICE, SIRONI GRAZIOSO, *Salaì and Leonardo's Legacy*, «The Burlington Magazine», vol. CXXXIII, 1055(1991).

SIGNORE GIANCARLO, *Alchimia, Evoluzione ed involuzione della Grande Arte*, Milan, 2017.

SMITH WEBSTER, *Observation on the Monna Lisa landscape*, «The art bulletin» LXVII(1985), n. 2.

SOEST MAGDALENA, *Caterina Sforza ist Mona Lisa: die Geschichte einer Entdeckung*, Kappelrodeck, 2011.

STARNAZZI CARLO, MAFUCCI CESARE, *Il paesaggio della Gioconda*, Arezzo, 1993.

STITES RAYMOND (ED.), STITES ELIZABETH (ED.), CASTIGLIONE PIERINA (ED.) *The sublimations of Leonardo da Vinci with a translations of the Codex Trivulzianus*, Washinghton, 1970.

TIRABOSCHI GIROLAMO, *Storia della letteratura italiana*, Venezia, 1824.

VASARI GIORGIO, FOSTER JONATHAN (ED.), *Lives of the most eminent painters, sculptors and architects*, London, 1871.

VASARI GIORGIO, MARINI MAURIZIO (ED.), *Le vite dei più eccellenti pittori, scultori e architetti*, Rome, 2009.

VASOLI CESARE (ED.), PISSAVINO PAOLO COSTANTINO (ED.), *Le filosofie del Rinascimento*, Milan, 2002.

VECCE CARLO, *Leonardo*, Rome, 1998.

VECCE CARLO, *La biblioteca perduta I libri di Leonardo*, Rome, 2017.

VILLA GIOVANNI C.F., *Leonardo pittore l'opera completa*, Milan, 2011.

ZAPPERI ROBERTO, *Monna Lisa addio: la vera storia della Gioconda*, Florence, 2012.

ZÖLLNER FRANK, *Mona Lisa del Giocondo*, «Gazette des Beaux-Arts» 121(1993).

WEB SITES

https://conservation-science.unibo.it/article/download/6168/5937

http://www.leonardodigitale.com/

https://restaurionline.wordpress.com/2017/01/30/le-copie-ovvero-le-versioni-de-la-gioconda-a-confronto-valutazione-storico-artistica-e-diagnostico-analitica-4-parte/

https://restaurionline.wordpress.com/2017/01/31/le-copie-ovvero-le-versioni-de-la-gioconda-a-confronto-valutazione-storico-artistica-e-diagnostico-analitica-5-parte/

https://restaurionline.wordpress.com/2017/02/01/le-copie-ovvero-le-versioni-de-la-gioconda-a-confronto-valutazione-storico-artistica-e-diagnostico-analitica-6-parte/

ABBREVIATION

ca.	circa
Ed./Edd.	edited by
e.g.	*exempli gratia*
f.	folio
ff.	followers
Fig.	figure
Id.	*idem*
i.e.	*id est*
n.	number
nn.	unnumbered
p./pp.	page/pages
r	*recto*
rev.	revised by
transl.	translated
v	*verso*
vol.	volume

INDEX

For expedience reasons the name of Leonardo da Vinci has been omitted.

Alberti Leon Battista: 54, 55
Albertini Ludovico: 107
Albertus Magnus, *saint*: 67, 85, 108
Alighieri Dante: 35
Al-Kindi (Abū Yūsuf Ya'qūb ibn Ishāq al-Kindī): 109
Angela Alberto: 120, 124, 125, 126, 130
Anonimo Gaddiano: 16
Apelles: 12, 119
Apicella Salvatore Andrea: 126
Archimedes: 99
Argan Giulio Carlo: 131
Aristotle: 35, 67, 70, 78, 80, 82, 85, 89, 99, 106, 108, 109, 128
Averroes: 67
Avicenna: 67, 105, 108, 130
Bacon Roger: 67, 108
Baglioni Raffacllo: 107
Barberini Francesco, *cardinal*: 22
Bellone Enrico: 129
Benci Ginevra: 10, 27, 38
Benci Tommaso: 76
Bernardoni Andrea: 71, 127, 128, 129, 130
Blaker Hugh: 45
Boreau Guglielmo: 17
Borgia Cesare: 31
Borzelli Angelo: 126, 129,

130
Botticelli Sandro: 112
Bramley Serge: 119, 130, 131
Brandani Pacifica: 15, 120
Brizio Anna Maria: 131
Buti Antonio di Piero: 120
Calvi Girolamo: 108
Caprotti Angelina: 18
Caprotti da Oreno Giovanni Giacomo, *detto Salaì*: 11, 17, 18, 19, 20, 24, 25, 40, 44, 47, 113, 120, 121, 122
Caprotti Laurenziola: 18
Cardone Francesco: 127
Casorati Benedetto: 122
Castiglione Pierina: 120
Cecco d'Ascoli: 108
Cellini Benvenuto: 99, 130
Chastel André: 130
Cicero (Marcus Tullius Cicero): 12
Clark Kenneth: 5, 34, 124, 129, 130
Cotte Pascale: 23, 45, 58, 125
Crevenna Pietro Paolo: 122
Crisciani Chiara: 130
Crivelli Lucrezia: 27, 121, 123
d'Adda Girolamo: 131

dal Pozzo Cassiano: 22, 23
d'Amboise Carlo: 11
d'Aragona Luigi, *cardinal*: 13, 15, 52, 117, 121, 123
d'Avalos Constance, *duchess*: 14, 120
d'Este Isabella, *marchioness*: 14, 120
da Sangallo Aristotele: 11
da Sormano Girolamo: 19
da Vinci Francesco: 11
da Vinci *ser* Piero, *notary*: 16, 24, 116, 121
Dan Pierre, *abbot*: 23, 24, 123
Dante: see Alighieri Dante
de Villanis Battista: 17
de' Beatis Luigi: 13, 14, 15, 17, 21, 22, 121, 123
de' Medici Giuliano, *duca*: 13, 15, 21, 44, 51, 117, 120, 121
de' Medici Hippolytus, *cardinal*: 15
del Giocondo Francesco di Bartolomeo di Zanobi: 6, 8, 9, 12, 14, 16, 23, 24, 51, 57, 119, 121
del Giocondo Lisa: vd *Gherardini Lisa*
del Giocondo Piero Francesco: 16

INDEX

del Giocondo Piero: 16
del Pollaiolo Piero: 112
del Sarto Andrea: 11
del Verrocchio Andrea: see Andrea del Verrocchio
De Santi Abati Agostino, 120
D'Orazio Costantino: 120, 125, 126
di Annone Bianca: 18
Doni Agnolo: 26
Doni Maddalena: 26
Duns Scoto Giovanni: 67
Empedocles: 65
Félibien André: 24, 123
Ficino Marsilio: 53, 76
Fioravanti Leonardo: 127
Fiorillo Flavia: 126
Forcellino Antonio: 119, 122, 132
Fornari Giuseppe: 128
Francis I, *king of France*: 8, 10, 17, 24, 99
Freud Sigmund: 120
Galen of Pergamon (*Claudius Galenus*): 68
Gallerani Cecilia: 27
Gates Bill: 33
Gaurico Pompeo: 99
Gelb J. Michael: 120
Gherardini Lisa: 4, 6, 7, 9, 12, 13, 15, 16, 21, 24, 34, 41, 46, 47, 53, 56, 58, 111, 112, 113, 116, 117, 118, 119, 120
Giontella Massimo: 121
Giotto di Bondone: 112
Giovanni dalle Bande Nere (Ludovico di Giovanni de' Medici): 107
Giovio Paolo: 12, 47, 119, 125
Groiler Jehan: 17, 121
Gualandi (o Gualanda) Isabella: 21, 120, 121, 123
Guglielmo di Ockham: 67
Guicciardini Francesco: 115
Guilbert l'Abbé: 24, 123
Halleaux Robert: 130
Heraclitus: 114
Hermes Trismegistus: 76, 98, 108
Hours Magdeleine: 15
Hume *sir* Abraham: 49
Irpino Enea: 120
Isaacson Walter: 14, 120, 122, 123
Jestaz Bernard: 20, 122
John of Rupescissa: 108
Kemp Martin: 5, 21, 32, 34, 35, 38, 43, 51, 54, 119, 121, 122, 123, 124, 125, 126, 127, 128, 129
Landino Cristoforo: 115

Index

Latini Brunetto: 35, 124
Lippi Caterina: 120
Lomazzo Giovanni Paolo: 20, 21, 47, 122
Lorenzetti Ambrogio: 112
Lorusso Salvatore: 125
Ludovico il Moro: see *Sforza Ludovico*
Machiavelli Nicolò: 12, 115
Maestro Giorgio: 131
Maestro Giovanni delli Specchi: 131
Maestro Leone: 131
Mafucci Cesare: 124
Malaguzzi Valeri Francesco: 131
Marani Pietro C.: 5, 21, 119, 120, 121, 122, 123, 124, 125
Marinelli Giuseppe: 122, 128, 129, 130, 131
Marini Maurizio: 119, 122, 130, 131
Marinoni Augusto: 130
Martelli Piero di Braccio: 11, 107
Masini Giovanni, *called Zoroastro da Peretola*: 107, 108
Matteucci Chiara: 126
Melzi Francesco: 17, 44
Merežkovskij Dmitrij: 100
Milizia Francesco: 126

Münz Eugéne: 129
Natali Andrea: 125
Nathan Johannes: 129
Nesi Giovanni: 99
Nicholl Charles: 129
Nicolò da Correggio: 115
Osborne Francis, *duke*: 49
Pallanti Giuseppe: 6, 21, 43, 119, 120, 121, 122, 123, 125
Paratico Angelo: 120, 130
Pater Walter: 5, 28, 29, 123
Paul of Taranto: 85
Pedretti Carlo: 5, 15, 32, 119, 124, 127
Pereira Michela: 130
Petrarch Francesco: 115
Philistion of Locri: 67
Pissavino Paolo Costantino: 127
Plato: 35, 65, 99
Pliny *the Elder* (Gaio Plinio Secondo): 115, 126
Ptolomy: 35
Prati Giacomo Maria: 95, 129, 130
Pulci Luigi: 11
Pulitzer Henry: 45
Pythagoras: 65, 99
Raffaello Sanzio: 26
Reti Ladislao: 95, 108, 129, 130, 131

Reynolds Joshua: 49
Richardson Jonathan: 49
Ristoro di Arezzo: 35, 124
Roberts Jane: 125
Rosci Marco: 125
Rossi Paolo: 130
Russel Peter: 129, 130, 132
Rustici Giovan Francesco (or Giovanfrancesco): 11, 107
Salaì: vd *Caprotti*
Sanzio Raffaello: vd Raffaello Sanzio
Sassoon Donald: 119, 125
Savoia Filiberta: 15
Scaillérez Cécile: 18
Schlecter Armin: 12
Seneca (Lucius Anneus Seneca): 35
Sforza Caterina: 14, 107, 120
Sforza Francesco, *duke*: 60, 72
Sforza Ludovico, *called the Moor, duke*: 17, 19, 31, 72 74, 110, 131
Sgarbi Vittorio: 5
Shell Janice: 121, 122
Signore GianCarlo: 130, 131
Sironi Grazioso: 122
Smith Webster: 124, 125
Soest Magdalena: 120

Starnazzi Cesare: 124
Stites Elizabeth: 120
Stites Raymond: 120
Tanaka Hindemici: 120
Valéry Paul: 100
Varese da Rosate Ambrogio: 131
Vasari Giorgio: 2, 3, 8, 9, 10, 11, 12, 13, 14, 15, 19, 22, 23, 25, 28, 39, 41, 42, 48, 51, 99, 106, 107, 113, 119, 122, 130, 131
Vasoli Cesare: 95, 127, 129
Vecce Carlo: 21, 31, 51, 123, 124, 128, 131
Venturi Adolfo: 120
Verrocchio Andrea: 28, 34, 60, 72, 106, 107, 113
Vespucci Agostino: 12, 13
Vespucci Amerigo: 12
Villa C.F. Giovanni: 126
von Leibniz Gottfried Wilhelm: 82
Xenophon: 126
Zapperi Roberto: 120
Zeusi: 54, 126
Zöllner Frank: 24, 119, 121, 129
Zoroastro da Peretola: see *Masini Giovanni*

www.ingramcontent.com/pod-product-compliance
Lightning Source LLC
Chambersburg PA
CBHW030007190526
45157CB00014B/912